THE WORLD TRADE CENTER

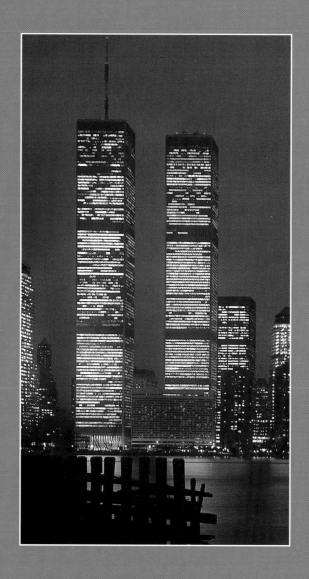

A Tribute

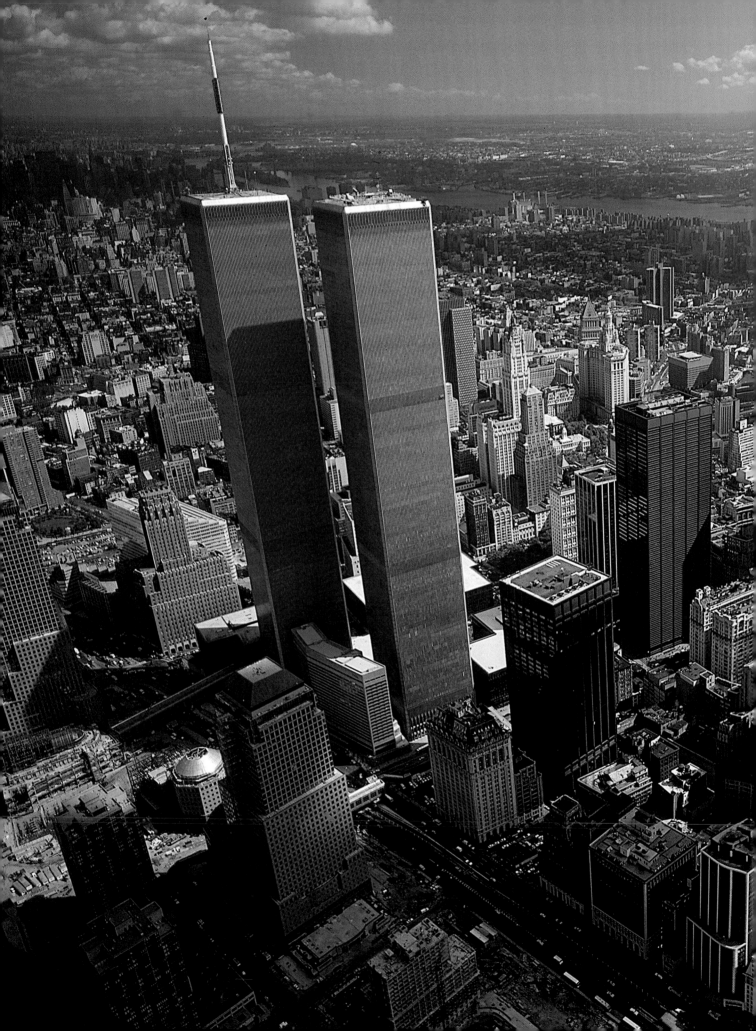

THE WORLD TRADE CENTER

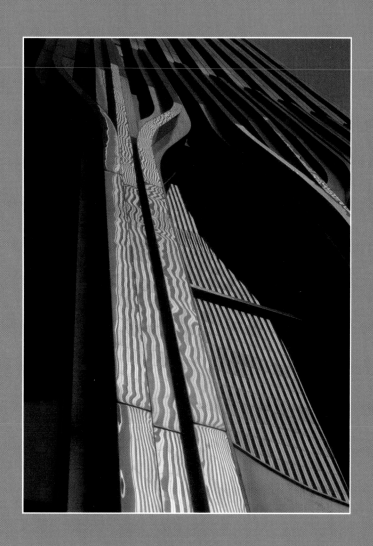

A Tribute

by BILL HARRIS

AN IMPRINT OF RUNNING PRESS
PHILADELPHIA · LONDON

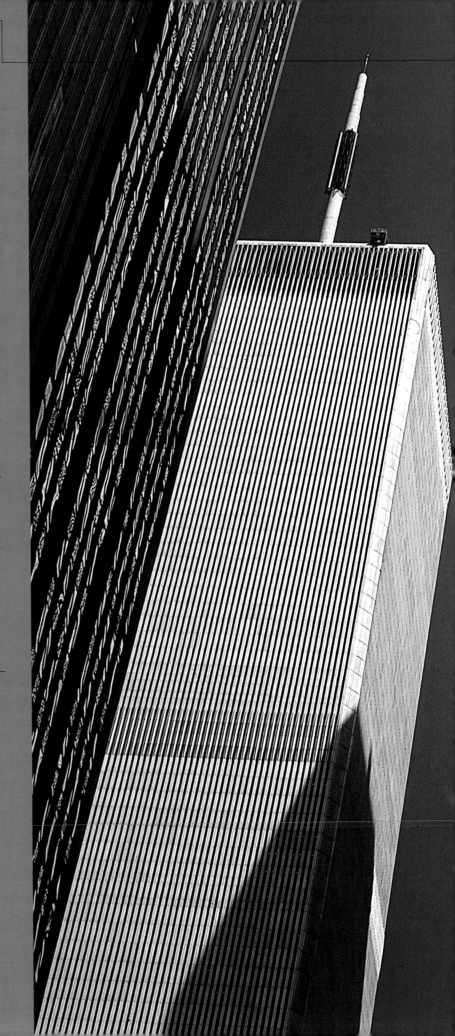

© 2001 Salamander Books Ltd
8 Blenheim Court
Brewery Road
London N7 9NY
United Kingdom

A member of the Chrysalis Group plc

This edition published in the United States by
Courage Books, an imprint of
Running Press Book Publishers
125 South Twenty-second Street
Philadelphia, Pennsylvania 19103-4399

9 8 7 6 5 4 3 2 1

Library of Congress Cataloging-in-Publication
Number 2001096782

ISBN 0-7624-1315-8

CREDITS

Editor: Jo Richardson
Designer: Mark Holt
Cover Design: Bill Jones
Picture Research: Terry Forshaw & Janice Ackerman
Commissioning Editor: Will Steeds
Production: Phillip Chamberlain
Color reproduction: Media Print, London, England

This book may be ordered by mail from the
publisher. But try your bookstore first!

Visit us on the web!
www.runningpress.com

Contents

Foreword By Peter C. Goldmark, Jr.

The World Trade Center was larger than life.

And it was ahead of its time.

We forget that in its early years the World Trade Center was immensely controversial and that many New Yorkers did not accept it right away. But it was conceived and built in the spirit of New York City, and like a New Yorker it elbowed and pushed its way into our midst and then into our hearts.

It was large, daring, and obtrusive, and its appeal and power did not lie in its own architecture or intrinsic beauty. Its meaning became evident only over time as it gradually assumed the role of anchor of the New York skyline and as the visual centerpiece of the brashest, most intense city in the world.

The Twin Towers stood for three decades as a reflection of fierce ambition and disciplined achievement on a massive scale. One tower would have been immense. The very fact of two bespoke breathtaking boldness and confidence. Because there were two towers, the World Trade Center dominated the skyline with both mass and equipoise.

The World Trade Center was a prism through which the colors of the natural world were transformed into the hues of the City. It cast back at us a thousand varied sunrises, sunsets, colored skies, and swirling cloudscapes, and it threw off light in startlingly different ways at different times in different seasons.

This book tells the story of the World Trade Center and of the City that came to accept it and to love it. It is a story of drive, of paradox, and of the inclusion of

a huge and multifaceted building project into the life of America's largest city.

It took tremendous drive and determination to build the Twin Towers. Perhaps only an agency with the focus, the financial strength, and the engineering competence of the Port Authority of New York and New Jersey could ever have designed and built the World Trade Center.

This fact created one of the lasting paradoxes of the World Trade Center. The towers that became a symbol to the world of Wall Street and American capitalism were in fact built and financed by a public agency as a public works program to spark the growth of downtown Manhattan. It is doubtful the private sector would have undertaken such a project.

But the real story of this book is the way in which the World Trade Center wove itself over the years into the tapestry of life in New York City, and the experiences, sights, and feats of all kinds that made it something continually special and surprising in our lives. It attracted tourists, gawkers, artists, photographers, journalists, traders, poets, schoolchildren, and daredevils, and in the end it attracted violence. It was an immense and vibrant mirror of New York's passions and reach.

The World Trade Center was larger than life and ahead of its time. And in that sense we will live now in the shadow of what it reflected about us and what it foretold about our City.

October, 2001

Peter C. Goldmark

Executive Director, Port Authority of New York and New Jersey, 1977–1985

7

Prologue

"I feel this way about it. World Trade means world peace and consequently the World Trade Center buildings in New York … have a bigger purpose than just to provide room for tenants. The World Trade Center is a living symbol of man's dedication to world peace … beyond the compelling need to make this a monument to world peace, the World Trade Center should, because of its importance, become a representation of man's belief in humanity, his need for individual dignity, his belief in the cooperation of men, and through cooperation, his ability to find greatness."

Minoru Yamasaki

Chief architect of the World Trade Center, 1976

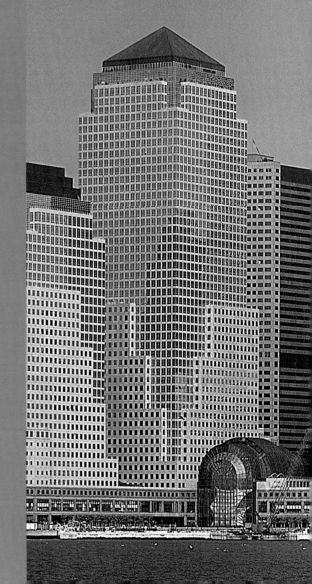

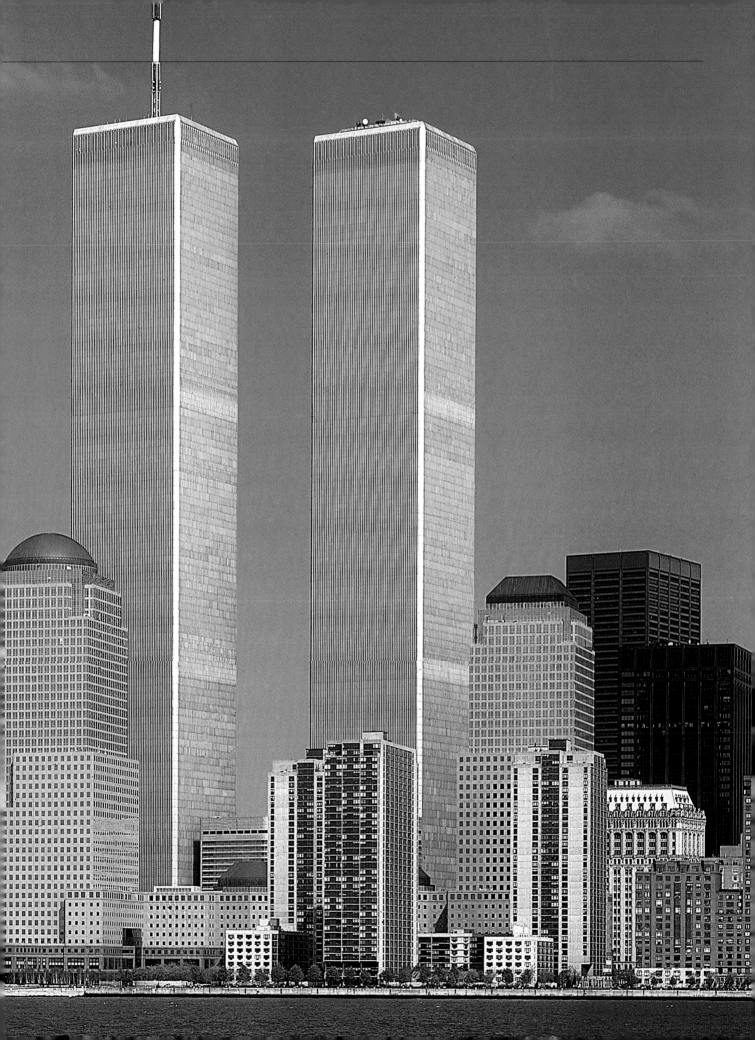

1 The Heritage

St. Paul's Chapel and its churchyard, on Broadway between Fulton, Church, and Vesey Streets, sits like a lonely little sparrow in the midst of the forest of skyscrapers of the city's Civic Center and its Financial District. It has been there since 1766, when its builders decided that Broadway would never amount to anything this far out of town and put its front facade on the opposite side facing the Hudson River.

RIGHT

Before New York had any skyscrapers, church steeples were the tallest structures in town. The one on St. Paul's Chapel was second only to Trinity Church.

FAR RIGHT

By 1831, uptown traffic had reached gridlock proportions, and St. Paul's Chapel, once a rural church, was in the thick of it.

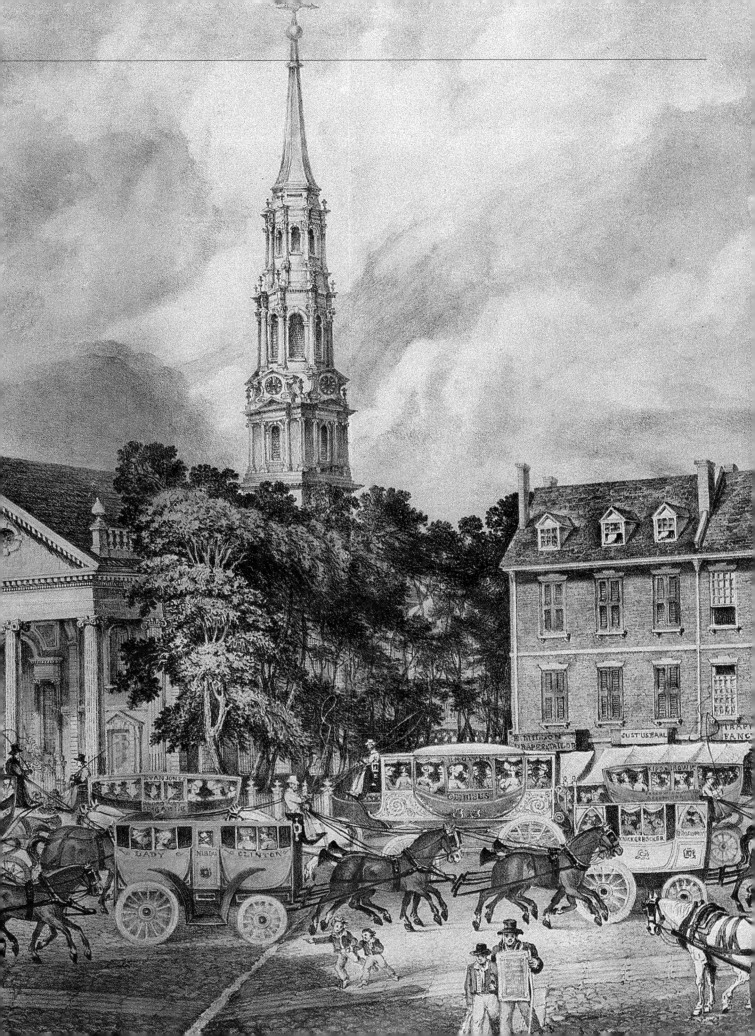

The towers of the World Trade Center provided a fascinating frame for St. Paul's Chapel and a touchpoint in tracing New York's architectural history. The graveyard behind the chapel was a charming place for people who worked in the Trade Center for turning their lunch hour into an occasion for a picnic.

When its steeple was added in 1794, St. Paul's was second only to Trinity Church as the tallest structure in the colony of New York. It was actually an outpost of the larger church, having been built as a mission to serve what was then the equivalent of a suburb of New York.

As the oldest public building still being used in modern New York, St. Paul's assumed a special importance in 1789 when George Washington attended for a special service of thanksgiving after his inauguration as America's first president on the steps of New York's City Hall nearby at Wall and Nassau Streets. He also became a regular Sunday worshipper there during the year that New York was the nation's capital.

Trinity Parish was the most influential church in early New York, and it still is one of the city's most important today. Apart from being the main American outpost of the Anglican Church during the days when New York was a British colony, it has been one of the wealthiest almost from the beginning, which is fitting considering its location on Broadway facing Wall Street.

It all began in 1705 when England's Queen Anne endowed the parish with a generous land grant that included all of the land west of Broadway between Fulton and Christopher Streets. The grant also included the right to claim the salvage from any ship that ran aground along the Hudson River, as well as any whales that might become stranded there. The church used the land, and the wealth it created, to help with the founding of more than seventeen hundred religious institutions for a host of denominations around the world, and it eventually gave away all but about six percent of its holdings, which was known as the "Queen's Farm," to churches of various faiths as well as to the city. But it is still formidable as one of New York's biggest landlords, with an annual income of well over $5 million from the land that underlies the manufacturing district north of Canal Street and into Greenwich Village.

FROM NEW AMSTERDAM TO NEW YORK

The original outline of Queen's Farm extended to the banks of the Hudson River, but it didn't include the eventual site of the World Trade Center. That was largely created by early landfills which pushed the river further west. It

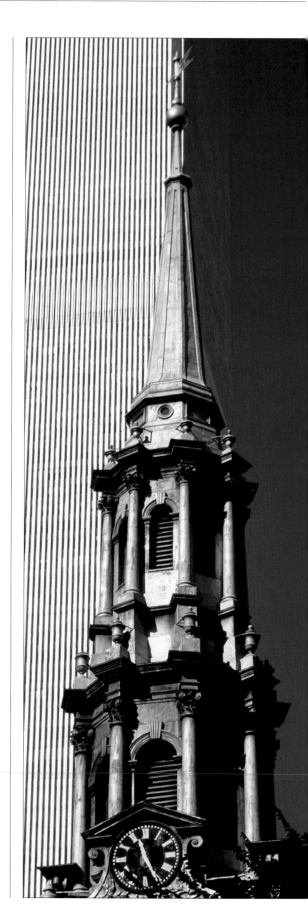

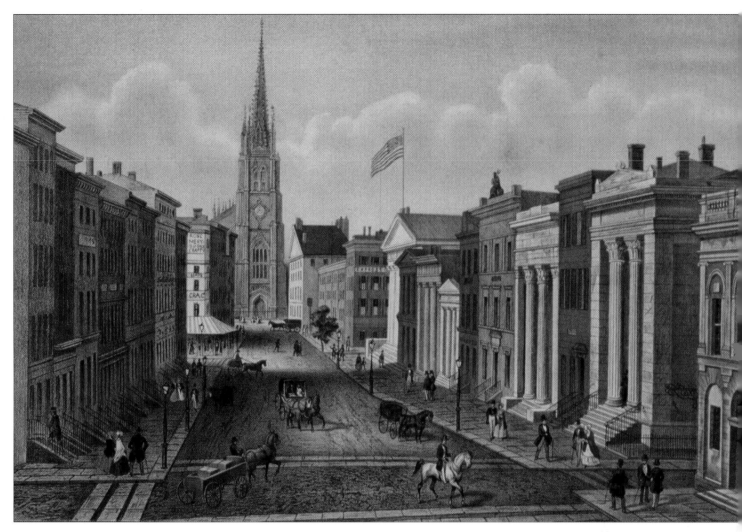

was part of a tradition established when the Dutch arrived at the lower edge of Manhattan in the early 1620s and called it New Amsterdam. In order to make it seem more like Old Amsterdam, they started right away to dig canals and the resulting debris was used to extend the shoreline, a bonus for the thrifty Dutch who, like modern New Yorkers, appreciated the idea of investing in real estate. The greatest of these canals was the Here Gracht, whose course is marked by present-day Broad Street, which not only follows its route but reflects its large dimensions.

After building a fort to protect their colony at the present-day site of the Alexander Hamilton Custom House on Bowling Green, they built a wooden wall at the northern edge of the settlement, following a line from river to river which is known as Wall Street today. Although the fortification is often remembered as a defense against Indians, the Dutch enjoyed

ABOVE

Trinity Church, on Broadway looking east down Wall Street, was the mother church of the Church of England, now the Episcopal Church, when New York was a British colony.

LEFT

The present-day Trinity Church, surrounded by the towers of the Financial District, is the third on the site. The first was leveled in the Great Fire in 1776; its successor's roof collapsed in a heavy snowstorm.

13

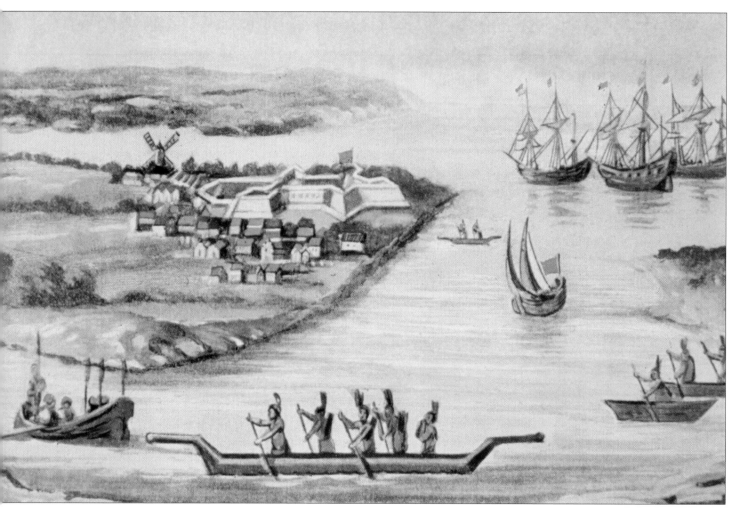

ABOVE

This engraving is purported to be the first view of New York, but it is actually Nieuw Amsterdam. In the beginning, everyone in town worked for the Dutch West India Company, which had a monopoloy on the colony's foreign trade. The bulk of the cargo was beaver pelts, eagerly gathered by the local Indians and sold to the company to satisfy Europe's lust for beaver hats.

relatively good relations with the Native Americans—they had, after all, paid them for the land they occupied, even if it was only twenty-four dollars, and they also eagerly bought all the beaver pelts their new neighbors had for sale. The feared enemy in this case was the British who were beginning to spread out over New England, even extending over to nearby Long Island, and from the very beginning were casting lustful eyes on the harbor at New Amsterdam, still one of the most important in the world.

It was the British who prevailed, of course. When Charles II became England's king, he magnanimously gave his brother James, the Duke of York, all of New Netherlands, the Dutch colony extending east of the Delaware River to the present-day state of Delaware on the south, to Albany on the Hudson River far north of the thriving settlement on Manhattan Island. Charles made the deal even sweeter by throwing in Long Island, Martha's Vineyard,

Nantucket, and Maine. But it was only a deal on paper. They had to contend with Peter Stuyvesant, the Dutch West India Company's Director General in New Amsterdam, a flinty old soldier who took his job very seriously indeed. Toward the end of August in 1664, a flotilla of British warships sailed into New York Bay, intending to take possession of the settlement "by threat or by shot." Although Stuyvesant prepared his soldiers to fire the first shot, and even tore the British demand for surrender into little pieces, the people of his colony, who had no particular loyalty to the Dutch West India Company anyway, forced him to surrender, and on September 9, the English raised their flag over Fort Amsterdam, and changed the colony's name to New York.

Then something odd happened. Nothing. Peter Stuyvesant was recalled to The Netherlands to explain his actions, and the Duke's agent, Colonel Richard Nicolls, became New York's first governor. The new owner had

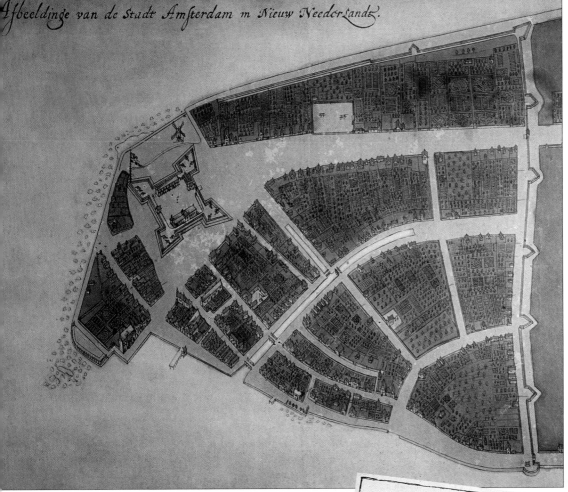

Afbeeldinge van de Stadt Amsterdam in Nieuw Neederlandt.

Birds flying over Manhattan in the seventeenth century had this view of the colony's defense structure, including Fort Amsterdam and the wooden wall along present-day Wall Street, intended to keep the New Englanders from trying to take over.

After all the Dutch efforts to fortify their colony's land approaches, as it turned out, the British attacked from the sea. It infuriated Director-General Peter Stuyvesant, who tore their surrender demand into tiny bits.

promised the citizens that nothing would change in their lives, and he was as good as his word. Under Dutch rule, they had been obliged to do business exclusively with the West India Company, but now they had a second trading partner in the English. Putting one over on the Dutch had become a municipal sport among the New Amsterdamers, and now the game was expanded. Their new masters even agreed to look the other way if New Yorkers turned to piracy, as long as the ships they hijacked were sailing under the flags of nations the British considered their enemy. Thanks to all these new opportunities, the concept of World Trade became the cornerstone of New York's economy for the first time. With a whole undeveloped continent at their back and the world at their feet, New York was on its way to greatness.

The city elected its first mayor, Thomas Willett, a year later, and gave him authority over all of Manhattan and not just the area

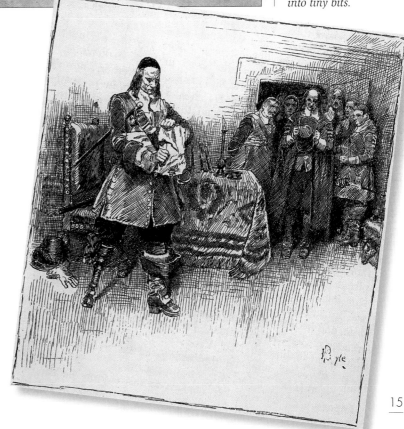

New York became the new country's financial center by following Alexander Hamilton's advice. The compromise he agreed to meant that it would no longer be the nation's capital, but few New Yorkers seemed to care. The town had been dedicated to the profit motive since the Dutch first arrived. To them, making money was a lot more fun than being involved in politics.

below Wall Street. It encouraged expansion, and by the beginning of the nineteenth century the waterfront had already begun to change dramatically as businesses began building along the East River and eventually to the reclaimed land along the Hudson.

CREATING THE COUNTRY'S FINANCIAL CAPITAL

The city's status changed again after the Revolutionary War when it became the country's first capital, largely as a result of lobbying by Alexander Hamilton, who was a delegate to the Continental Congress, as well as a highly successful lawyer. It was in his own best interest to locate the government in New York because he was not only one of the city's greatest boosters but was also a founding director of the Bank of New York, the only one in town.

Although Congress liked doing business in New York, some of its leaders—men like Thomas Jefferson and even President Washington himself—thought that the capital ought to be located somewhere else, someplace like their native Virginia. Hamilton had worked hard to bring them to New York,

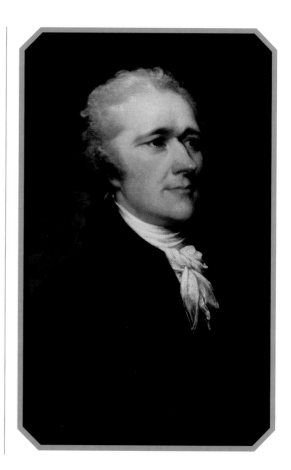

Tradition has it that the New York Stock Exchange had its beginnings when a group of merchants, bankers, and securities traders gathered under a buttonwood tree on Wall Street in 1792 to establish rules for the buying and selling of stocks and bonds.

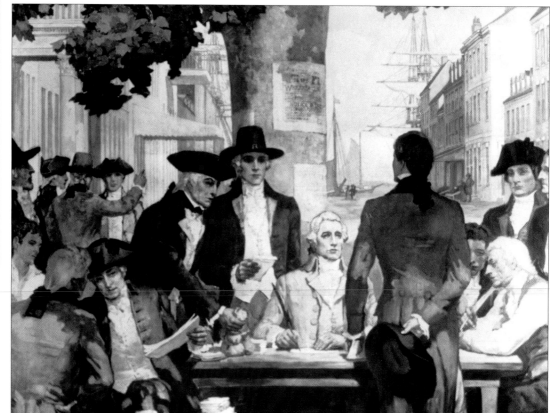

but he had a bigger dream and he was willing to compromise. It was a dream that he began to put into action when he was made Secretary of the Treasury.

The Continental Congress had financed the war with Britain by borrowing money from the individual colonies, but few of the debts had been repaid and most Americans resented owing money to the Federal Government, which few of them had any reason to trust. Hamilton was a dedicated Federalist, and he believed that the problem could be settled once and for all if the country's economy became based on manufacturing rather than agriculture, as it had been in colonial times. If the focus were to be changed, he told his fellow representatives, then they could put the capital wherever they wanted it to be. Then he put his money where his mouth was. His Bank of New York granted a $200,000 loan to the cash-poor government, and his ideas for financing the country became national policy.

It made New York the country's financial capital, which was what Hamilton had in mind all along. When the government began issuing bonds to help cover its debts, investing in them

became a national mania, with New York speculators manipulating the price. Then it all came to a crashing halt. When farmers and storekeepers started turning to expensive bank stocks as a means of making even more money than they could realize through government bonds, a scoundrel named William Duer accommodated them with high-interest loans that made it look easy.

After Duer went bankrupt and was jailed on charges of usury in 1792, crowds of ruined investors from as far away as Boston and Philadelphia descended on New York with every intention of lynching him. But it was too late. The damage had already been done, the bubble had burst, and Duer was safely behind bars. Recovery came quickly, though, and Hamilton turned the crash into an opportunity. Noting that William Duer would spend the rest of his life in jail where he couldn't hurt anybody, Hamilton made a solemn promise to all America that New York would always deal with such "knaves and gamblers" in exactly the same way, and that industrious citizens should be careful only to invest their money through New York institutions. The message was taken

The Tontine Coffee House was the headquarters of the New York Insurance Company, a precursor of the Stock Exchange. Each of the 21 members of its board of directors agreed to combine their own assets, with each member sharing equally in the profits of all, the percentage increasing as death reduced the number of partners.

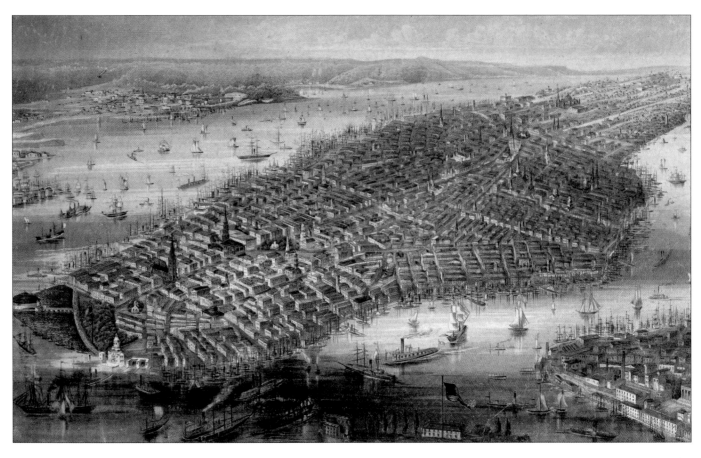

ABOVE

During the early years of the nineteenth century, Manhattan was bursting at the seams and beginning to expand northward. Expanding upward would come a few years later. Then, as now, it was a city of walkers, and as businesses moved into new buildings further from the traditional center, their employees moved into new houses nearby.

to heart in every part of the country, and New York became America's undisputed financial center almost overnight.

To cement their importance and to establish rules that would keep them on the cutting edge of serving the needs of investors, a group of brokers and merchants met under a buttonwood tree on Wall Street and hammered out an agreement among themselves which eventually led to the formation of the New York Stock Exchange. Today it is America's, and the world's, principal securities market, handling the exchange of the stocks of some 2,500 firms, representing more than eighty-five percent of the capitalization of all the publicly-held equities in the United States.

EXTENDING THE INFLUENCE

But for all that, New York didn't become the world's most important trading city until 1825 when an armada of twenty-two steamships towing canal boats sailed down the Hudson River and into the harbor at the end of a voyage all the way from Buffalo on the far-off shores of Lake Erie. It had completed the trip in an amazing nine days.

The engineering feat that made it possible was the Erie Canal, a ditch four feet deep and forty feet wide (1.2 by 12m) cut through the wilderness of upstate New York for 350 miles from Buffalo to Albany, where it connected with the Hudson River. No one believed it would be possible to build such a thing. In some places, immigrants brought over from Ireland to do the job had to dig through solid rock with picks and crowbars, and a bit of gunpowder to make the job a little easier by blasting away the most stubborn of the obstacles. In other places, they had to slither through bogs, swamps, and wetlands. But if it all seemed too incredible to the average man on the street, no one doubted that it was worth the effort.

As the country pushed westward, produce from its midlands was shipped down the Mississippi River to the French-controlled port of New Orleans or north through the British-dominated St. Lawrence River, and New York was generally on the outside looking in. After the Louisiana Purchase turned New Orleans into an American port, New York was drifting even further toward second-class status because

it cost as much to ship a ton of goods thirty miles overland to its port as it did to reship it the rest of the way to England. The canal seemed well worth the eight years of hard labor and the $7.6 million it cost to build it. When the steamboats arrived, New York was finally on its way to becoming the world's most important seaport. But nobody ever doubted that it would.

The promise was kept in an impressive way. By the mid-nineteenth century, there was more traffic on the Erie Canal than on the whole Mississippi River system put together, with more than 150 boats carrying freight and passengers in and out of New York each and every day. The Port of New York was handling a third of all the export business in the entire world by then.

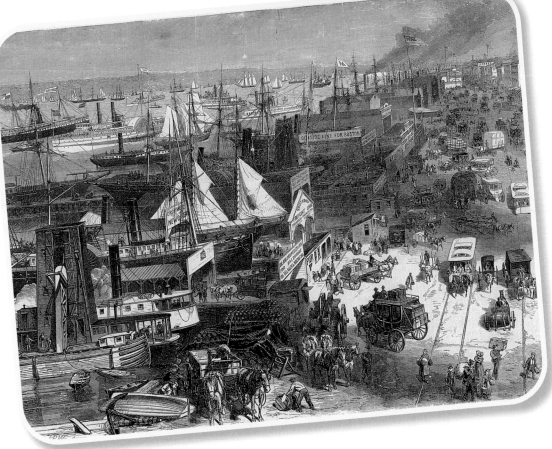

The Erie Canal represented a sea change in New York's fortunes as a world trader. By carrying tons of goods down from America's heartland around the Great Lakes faster and cheaper than any other means, it made the Port of New York the world's richest.

By 1869, the port was choked with traffic, from sailing vessels to steamboats. Transatlantic ships returned with paving stones in their holds as ballast, providing an endless supply for the many new streets in Manhattan.

RIGHT

Cornelius Vanderbilt got into the railroad business when he was nearly 50 years old. At the time, he estimated his fortune at $50,000, a tidy sum in 1840. Eight years later it had grown to $11 million.

BELOW

By 1880, the view of Manhattan from Castle Clinton and Battery Park was beginning to look like a real city. Construction of the Brooklyn Bridge was completed in 1883.

THE GROWING SKYLINE

The opening of the Erie Canal spurred much more than the growth of New York's shipping interests. Within six months, more than five hundred new businesses, including banks and insurance companies, were established in the city, and the New York Gas Light Company began lighting up the streets for all those office workers who were having to work overtime to keep up.

It created a building boom in lower Manhattan. These new arrivals needed office space, and because nearly everyone walked to work in those days, new housing was needed close by as well.

Over on Wall Street, men like Cornelius Vanderbilt were investing heavily in railroads, and before long, New York was connected to Chicago with new lines that brought more freight and more lucrative business to New York. It also transformed Chicago into a boom town. After it was nearly totally destroyed by

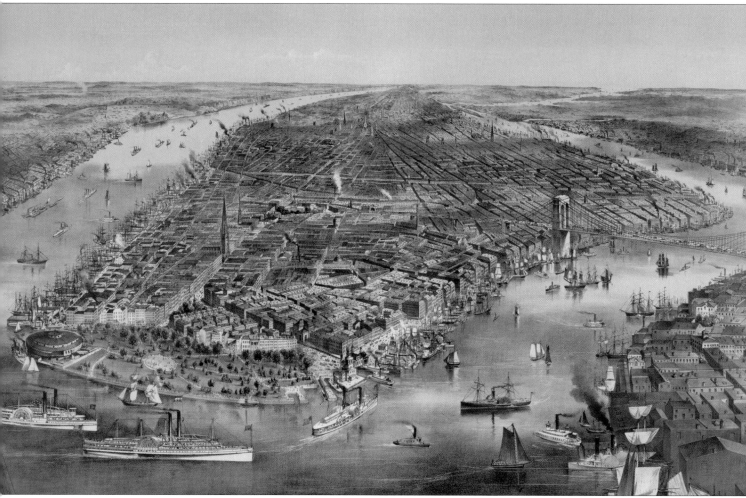

the Chicago Fire in 1871, architects there had a clean slate, and they had an idea. Like New York, its possibilities for growth were limited by geography. There was a small amount of space and a large amount of demand, and men like Louis Sullivan and Daniel Burnham decided there was no way to go but up. William LeBaron Jenney led the way in 1885 with the Home Insurance Company Building, the first ever to be built around a skeleton of iron columns which allowed its weight to be evenly distributed on the interior rather than through exterior masonry walls. It meant that the outer walls could be thinner, not to mention lighter, and it was possible to get more rental space inside. Thinner walls also allowed for more windows, making the interior even more desirable, but the biggest advantage was that there was virtually no limit to how high an iron-framed building could go. As if to prove the point, two more stories were built on top of it in 1891. As originally built, the Home Insurance Building was only 180 feet (55m) tall, hardly qualifying as a skyscraper by today's standards, but it was high enough to inspire more like it.

Three years later, New York entered the race for the sky with the 13-story, 160-foot (49m) Tower Building at 50 Broadway. Prospective tenants thought such a monster wouldn't work because it would soon share its side party walls with others like it, leaving only the front elevation open to natural light. The builders countered by making it look like a freestanding tower, though, and carefully gave its facade the illusion of having thick exterior loadbearing walls, just like old-fashioned buildings. It didn't exactly overcome the objection, but the novelty alone was enough to have it fully rented almost overnight.

THE NATURAL ADVANTAGE

Although Chicago had the idea of skyscrapers almost all to itself in the beginning, it didn't take long for New York to catch up, and in the century since, it has built more, and generally taller, towers than its sister city in the Midwest. Among the reasons is the unique geology of Manhattan Island.

Thousands of years ago when the great glaciers crept down from the north, they ground down a former mountain range that was spread over most of what is now the northeastern United States. In the case of what

By the 1890s, Trinity Church was eclipsed by tall buildings lining Wall Street, already the center of the action. Scenes like this were usually compared to the canyons of the Wild West, but what went on inside was far wilder.

As the city grew northward, streetcars began running along former stagecoach routes, and in 1885 the first self-propelled vehicles began to appear on Broadway.

In the 1940s, before the downtown renaissance that came a decade later, the skyline looking west across the South Street piers was quite different than it is today.

we know as the New York Metropolitan area, the ice sheet took the mountains completely away, leaving only their foundations, and then came to a halt, slowly melting and leaving behind enough debris to create Long Island. The underground rocks that had supported those mountains were left close to the surface. They had been compressed to a kind of flinty stone that is so common in New York City that

it goes by the name of Manhattan Schist.

On the island of Manhattan, the bedrock is relatively close to the surface all the way up SoHo, where it becomes overlaid with more soil. In the area that is now Greenwich Village, the foundation stone dives down even deeper, and doesn't re-emerge until it reaches the midtown area. That is why the Manhattan skyline is made up of massed towers at the

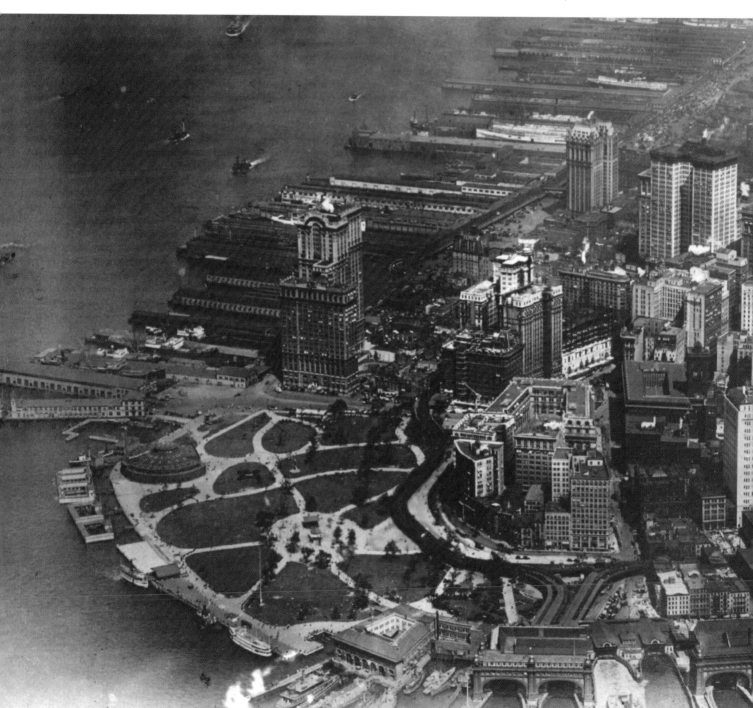

lowest end, with a long gap before growing again with the Empire State Building and its skyscraper neighbors.

The schist, though very hard for stonemasons to cut, was the building material of choice for many of the city's oldest church buildings. But the best place to reach out and touch it is on the Upper West Side, especially in Central Park, where it begins to rise above the surface.

In fact, its presence was one of the factors that slowed development of the West Side. The rock had to be blasted out, not only for building foundations, but to build streets and excavate water and sewer lines. The vein keeps rising out of the ground as it progresses north, and in some parts of Morningside Heights and Harlem, there are places where developers despaired of removing it for building sites.

Chicago, on the other hand, was built on relatively marshy ground, and its skyscrapers had to be constructed on underground structures that resemble the hull of a boat and literally float above the subsoil. The solution works, to be sure—just take a look at the Chicago skyline. But nothing beats solid bedrock, and that is why New York is a skyscraper kind of town.

BIG BEGINNINGS

New York's oldest skyscraper still standing, the 285-foot (87m) Flatiron Building, was built on Manhattan's Madison Square in 1902, on designs by Chicago architect Daniel Burnham. Along with his partner, John Wellborn Root,

Although there were taller towers in New York when the Flatiron Building went up in 1903, none of them captured the public's fancy in quite the same way—a love affair that continues to this day. Its odd shape was determined by the diagonal uptown march of Broadway across the street grid, forming Madison Square here at 23rd Street, and Times Square to its north.

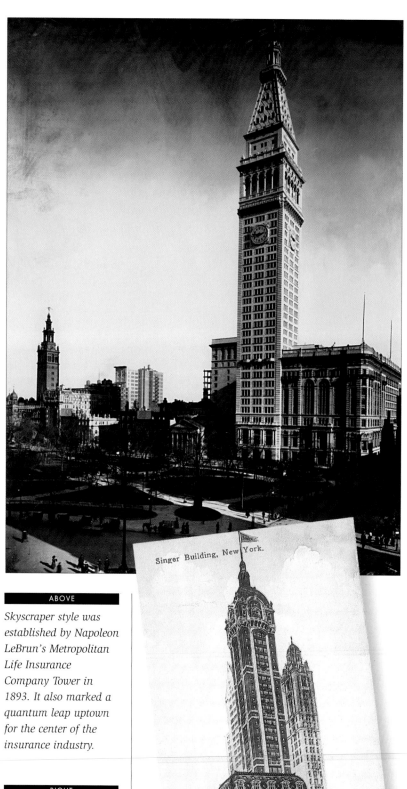

Singer Building, New York.

Skyscraper style was established by Napoleon LeBrun's Metropolitan Life Insurance Company Tower in 1893. It also marked a quantum leap uptown for the center of the insurance industry.

Until it was demolished in 1970, Ernest Flagg's Singer Tower added a graceful note to the downtown skyline.

Burnham had already designed Chicago's innovative Rookery and Monadnock Buildings, but in New York, he turned to ornate Classical detailing rather than the native exuberance of his hometown. It set the stage for all subsequent New York skyscrapers, which looked to Europe, especially France, and not America for their inspiration.

The buildings they built were made to be impressive beyond their soaring presence. They were designed to make a statement that their owners were the biggest in their field and to convey the idea that, while they were powerful, they were also sensitive to the need for beautifying the city.

The next major New York skyscraper was the Metropolitan Life Insurance Company Tower, also on Madison Square, completed in 1909. At 700 feet (213m), it dwarfed its neighbor across the square, and everything else in the world, for that matter. It was the tallest building in the world until 1913, when New York's Woolworth Building rose up another 92 feet (28m) into the air. Met Life used a stylized drawing of its tower, modeled after the Campanile in Venice, as its corporate symbol for generations, and F.W. Woolworth, whose Gothic-inspired building, designed for him by Cass Gilbert, was called the "cathedral of commerce," made certain that everyone knew that he had paid cash for it.

The Met Life Tower took the record of world's tallest away from another building at the corner of Broadway and Liberty Street, just a block from the eventual site of the World Trade Center. Ernest Flagg's Singer Tower held the title of tallest for slightly less than a year. A beautifully designed skyscraper, it established a different sort of record in 1972 when it became the tallest building in the world ever to be demolished. Its replacement, One Liberty Plaza, hardly seemed worth the loss.

BUILDING MONUMENTS

The mania for capturing the public's imagination by building the tallest tower in the world reached its peak in the 1920s. *The New York Times* noted a few years later that, "Even before the great crash and the great depression, the skyscraper was under suspicion from the standpoint of sound economics. It did not always pay for itself as a renting enterprise. A large part of the return was supposed to be in advertising. But for that purpose a skyscraper

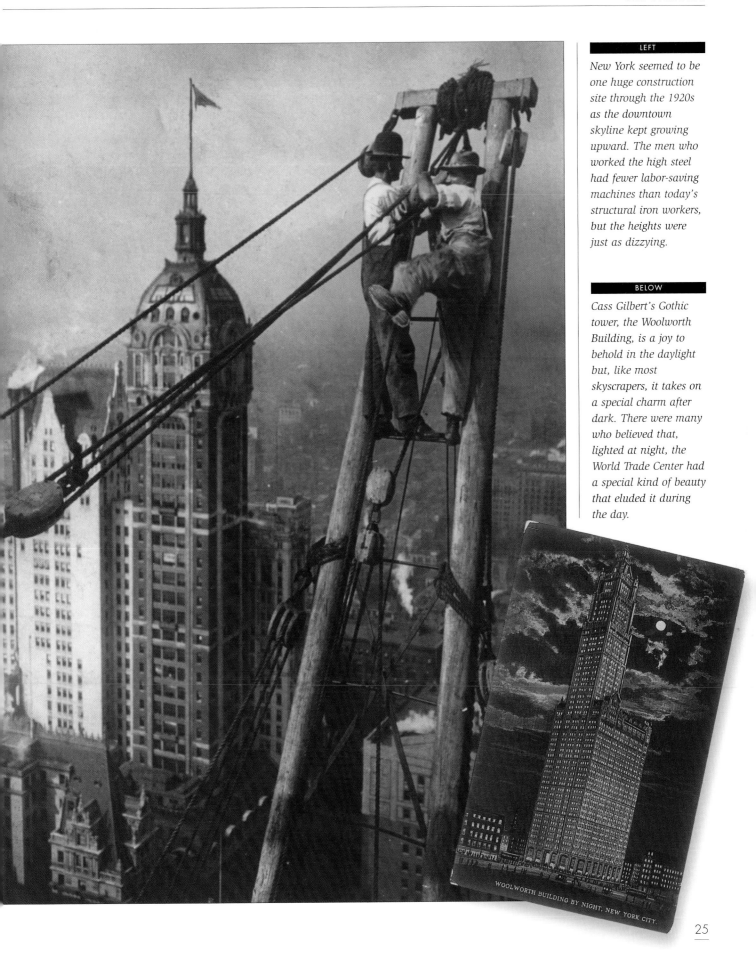

New York seemed to be one huge construction site through the 1920s as the downtown skyline kept growing upward. The men who worked the high steel had fewer labor-saving machines than today's structural iron workers, but the heights were just as dizzying.

Cass Gilbert's Gothic tower, the Woolworth Building, is a joy to behold in the daylight but, like most skyscrapers, it takes on a special charm after dark. There were many who believed that, lighted at night, the World Trade Center had a special kind of beauty that eluded it during the day.

WOOLWORTH BUILDING BY NIGHT, NEW YORK CITY.

One of the forces that drove the building of skyscrapers in the 1920s was making statements about the power and might of the companies that would occupy them. In the case of the Chrysler Building, though, it was a monument to a single man, Walter P. Chrysler, whose automobile empire had already made his name a household word.

Construction of the Chrysler Building was completed in 1930. It began as a speculative building by a Coney Island developer, who sold the leases and early plans to Walter Chrysler in 1927. The original plan was altered considerably.

had to be more than tall. It must be taller or tallest. People were not erecting high buildings, but higher buildings, presumably for the world to look at and talk about and only subsequently for people to dwell in." But that was hindsight. In the heady days of the 1920s, the rush to build bigger buildings seemed like the best possible statement a company could make.

The rush gained full steam in 1926 when a builder promised that a tower 500 feet (152.5m) taller than the Woolworth Building would be built in midtown, but although the project was abandoned, it inspired others to try for the same majesty. Among them was Walter P. Chrysler, who ordered plans for a building that would not be the headquarters of his Chrysler Motors Company, but rather an unabashed monument to himself. His architect, William Van Alen, was more than happy to accommodate him, but no sooner had he announced his plan than a rival developer countered with an announcement that another building a block away, the present-day Lincoln Building west of Grand Central Terminal, would rise up to fifty-five stories. Van Alen didn't bat an eye and countered with a proposal of his own to make his Chrysler Building fifty-six floors above the street. His competitor upped the ante

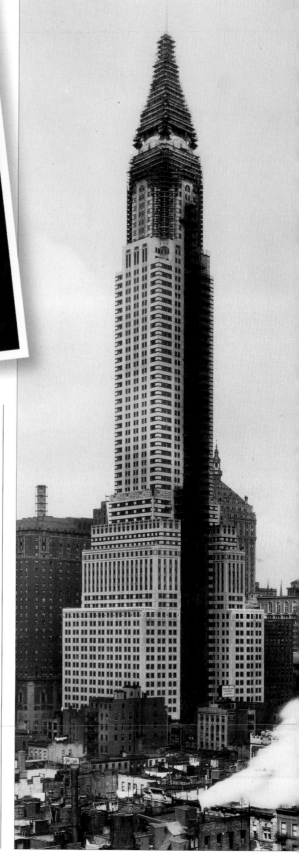

to sixty-three stories, and Van Alen met the challenge with sixty-five. But it was all just a poker game. The Lincoln Building didn't soar more than fifty-four floors, and most likely it was never intended to be any taller.

Van Alen had a more serious competitor, though. His former partner, H. Craig Severance, had a commission to build a tower in the Financial District for the Bank of the Manhattan Company, and both architects announced on the same day that they were planning to build the world's tallest building. They couldn't both be right, of course, and

Chrysler prodded Van Alen back to the drawing board. It was good publicity, after all—just what a personal monument was all about. The result was a reworking of the Chrysler Building's crown and the addition of a few more floors. No sooner had the new plan been announced, though, than Severance secured a permit to add a decorative lantern to the top of his sixty-story building, and then planned to add a 50-foot (15m) flagpole to the top of it. Then he proceeded to top off his building, which rose up to 927 feet (282.5m) and captured the record. Although the Chrysler

The 1936 skyline of the Grand Central area was dominated by the Chrysler Building, but also included the Lincoln Building on 42nd Street, the Chanin Building on Lexington Avenue, and the Daily News Building further east along 42nd Street.

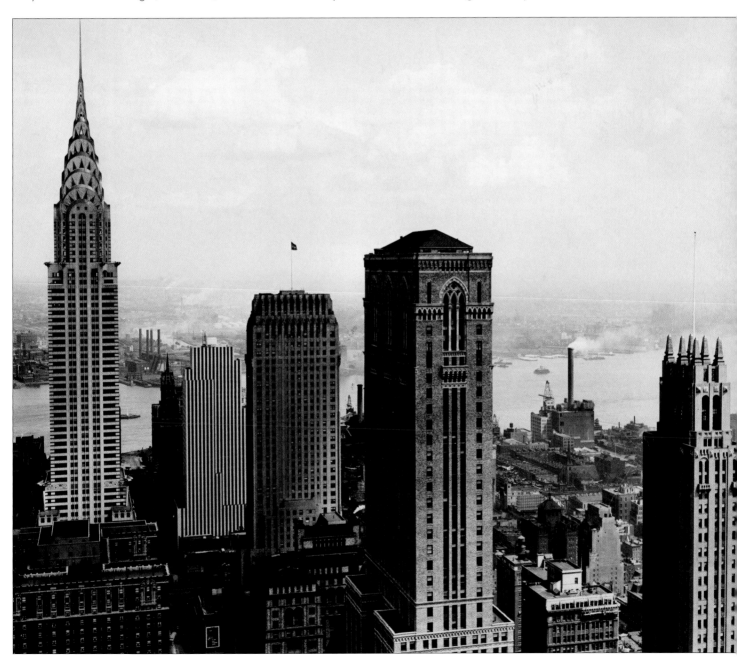

ABOVE

New techniques allowed workers to finish the Empire State Building forty-five days ahead of schedule and $5 million under budget. At one point, 3,500 workers were on the job, and in one ten-day period, a staggering fourteen stories were framed.

tower was nearly finished by then, and it didn't seem possible for it to go any higher, Van Alen ceremoniously pulled a trump card from up his sleeve. Anticipating trickery from his former partner, he had secretly built a 185-foot (56m) stainless steel spire inside the fire shaft of his building, and as soon as Severance called his skyscraper finished, Van Alen raised the spire up through the dome of his tower, and in less than two hours he and Mr. Chrysler could boast of having built the world's tallest building. They had managed to push a total of 1,048

feet (319.5m) into the air—far and away higher than Severance's touted masterpiece, and even higher than the Eiffel Tower, which rises only 986 feet (300.5m) above the streets of Paris.

The victory was only short-lived, though. Less than a year after Van Alen relocated his offices to the top of his masterpiece, he found himself looking out at the Empire State Building. It would be the world's tallest until the twin towers of the World Trade Center were finished forty-six years later.

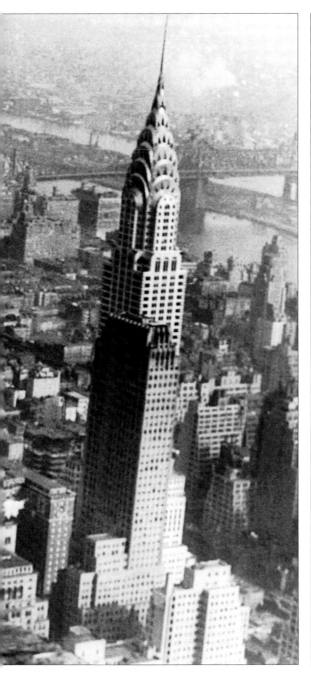

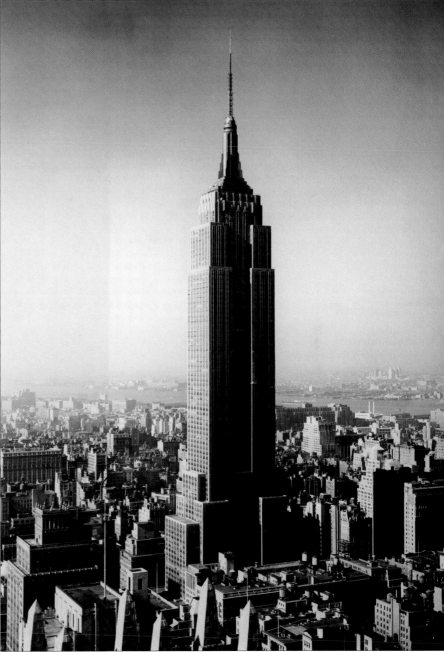

REBUILDING DOWNTOWN

Replacing its buildings has been practically an epidemic in New York since colonial times. There are no traces at all of the buildings the Dutch built in the seventeenth century, nor of the improvements the English brought to the cityscape. Many of those structures, some 493 of them, were destroyed in the Great Fire of 1776, which leveled a third of the city. Disaster hit again in 1811, when fire once again swept through lower Manhattan, destroying 102 buildings and crippling

business for months afterward. As has happened before and since then, New Yorkers just rolled up their sleeves and started rebuilding, creating a city that was more impressive than it had been before.

But most of the building activity in the Financial District around Wall Street and the Insurance Center surrounding John Street ground to a halt after the Great Depression and the one-two punch of World War II. With the rush to the suburbs after the war, companies that seemed solidly anchored to downtown

The Empire State Building was the world's tallest until the Twin Towers were built. It became two hundred feet (61m) taller in 1953 when a television transmitting tower was added.

RIGHT

The rush to build taller buildings came to a screeching halt on "Black Thursday" in October, 1929 when Wall Street's fortunes went into a nosedive.

BELOW

The Chase Manattan Building jump-started downtown construction after its last steel beam was put in place in September 1959.

BELOW RIGHT

David Rockefeller, Chase Bank's president, was the driving force behind the downtown renaissance and establishment of a World Trade Center.

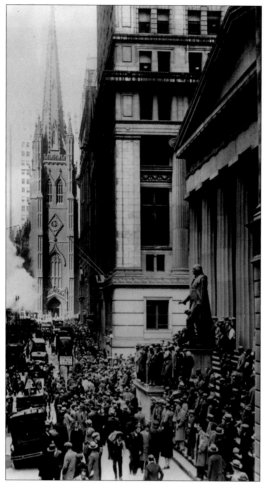

began relocating in midtown to accommodate their commuting employees. Not a single new building was added to the downtown skyline between 1929 and the early 1950s.

The few structures that were eventually built were largely unimpressive, and observers of the real estate market began grimly predicting that lower Manhattan was inexorably on its way to becoming a ghost town. Then, in 1955, the Chase Manhattan Bank announced plans to consolidate nine different locations and 8,700 employees into a sixty-story skyscraper it would build on land facing Liberty Street. Construction began two years later and the tower was finished in another three years.

The hope it represented encouraged a boom in downtown construction, but most of what was built was nothing less than banal, until 140 Broadway, next door to Chase's triumph, was announced in 1961. Like the Chase building, it was designed by the firm of Skidmore, Owings, & Merrill, which set out to complement, if not top, the Chase project. A sober building, relieved by a huge sculpture in the form of a red cube by Isamu Noguchi, the building, now named for its major tenant, HSBC Bank, rises a sheer 677 feet (206m) from the sidewalk. Along with its neighbor, it seemed to have brought good taste back to the downtown architectural horizon.

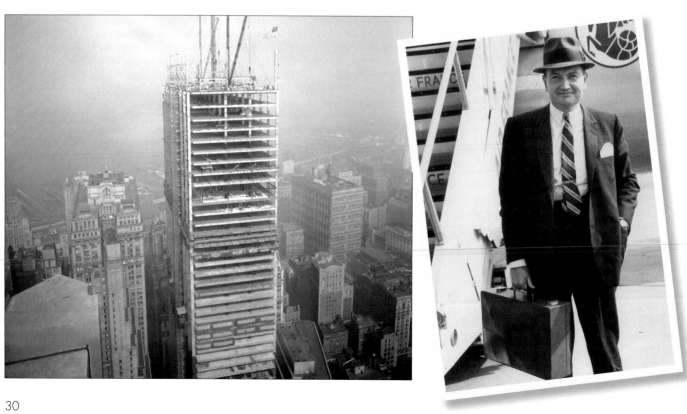

The problem was, though, that while the Financial District was revitalized as a place to work, it wasn't exactly what Chase-Manhattan president, David Rockefeller, had in mind when he started the ball rolling. He knew that the area needed to diversify, and began trying to convince others that what was really needed was a new emphasis on world trade. It was an echo of the philosophy of his father, John D. Rockefeller, Jr., whose dream for the Rockefeller Center was rooted in promoting trade among nations by providing foreign banks and governments with a base in America. World War II dashed the dream, but it was never really dead.

In 1960, David Rockefeller began breathing life into it again when the Downtown-Lower Manhattan Association, which he headed, issued a wide-ranging plan to build what they characterized as a World Trade Center. As far as their supporters were concerned, it was an idea whose time had come.

The World Trade Center was the continuation of a dream by John D. Rockefeller, Jr., who believed that New York's future depended on reaching outward and cooperating with foreign governments and businesses. He pushed the dream forward at his Rockefeller Center with the International Building on Fifth Avenue and others flanking it, hoping to attract international tenants. War in Europe put the dream on hold.

2 The Plan

The first plan for New York's World Trade Center was unveiled by the Downtown-Lower Manhattan Association in January, 1960. It called for a combination office and hotel building up to seventy stories high, which would be built along the East River next to the present-day South Street Seaport, just north of the city's Financial District.

RIGHT

As the Twin Towers began to rise in the 1960s, the landfill it added to the shoreline was the beginning of the future of the Battery Park City and the World Financial Center.

FAR RIGHT

Before construction began, architect Minoru Yamasaki translated his designs into working models of both the site and the neighborhood.

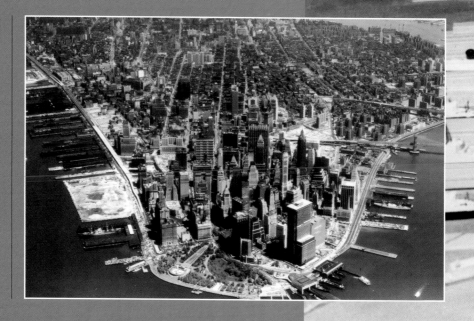

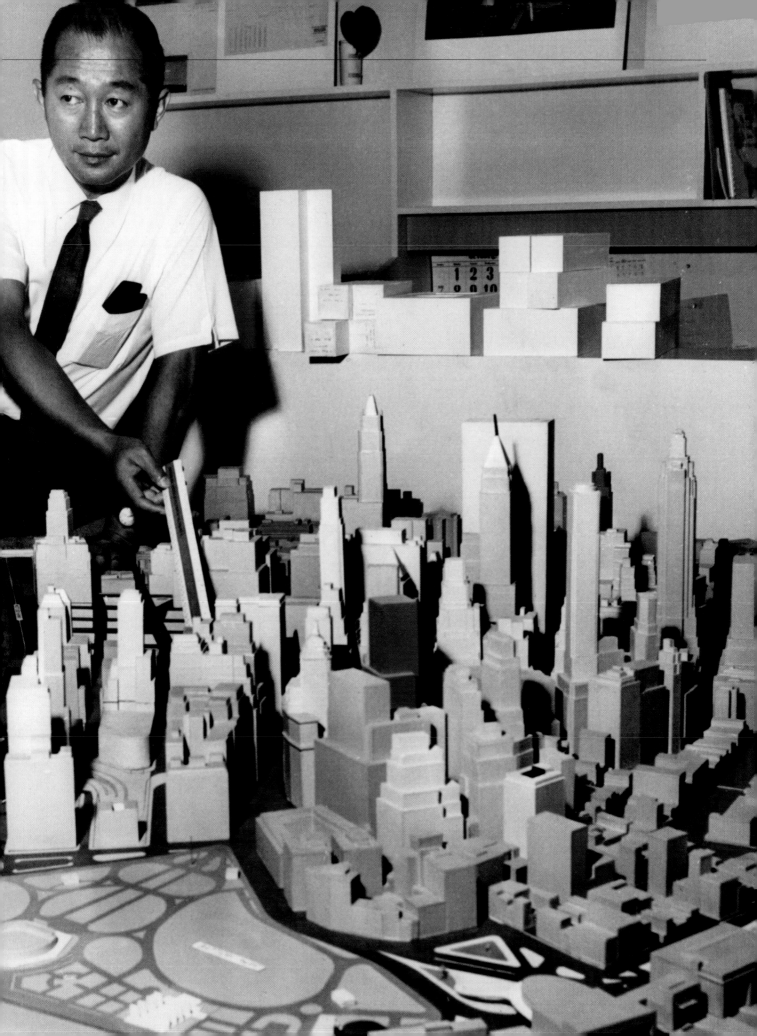

Along with a six-story building intended to house a world trade mart, exhibition space, and a new home for the New York Stock Exchange, the tower would sit on top of a three-story base, which would include a shopping arcade with restaurants and theaters. The roof of the platform would provide a riverside promenade.

As part of the proposal, the plan integrated Brooklyn Bridge Southwest, a development of 21,000 housing units that was already in the planning stages. As the proposal noted, the area to be redeveloped would no longer be "a commercial slum right next to the greatest concentration of real estate value in the city." David Rockefeller couldn't contain his enthusiasm, calling it "the hottest thing I'm involved with."

BRINGING THE PORT AUTHORITY ON BOARD

The Association's report noted that planning would be assisted by the Port Authority of New York and New Jersey, and a year later the agency issued its own report, which announced that it was going to pursue the project without any delay. The Authority had been created by the New York and New Jersey legislatures in 1921 in response to what seemed to be the inevitable decline of the port. It was a regional planning organization first and foremost, but it was also the earliest example of a corporation operating within the public sector, since imitated in cities all over America, that had the means of channeling private funds into public works. It was the model for the depression-breaking programs that President Franklin D. Roosevelt called the "New Deal." The port district the agency oversees covers more than 1,500 square miles (3,885km²) within seventeen counties and 108 municipalities.

The organization, which was known as the Port of New York Authority until 1972, was chartered to improve terminals in the port and the transportation facilities that served them, and its commissioners were given broad authority to issue bonds and to charge fees to support their efforts. Its first major construction project was the Outerbridge Crossing over the Arthur Kill, to connect Staten Island with Bayonne, New Jersey, opened in 1928. Although its name suggests its location, it was actually named for the Port Authority's first chairman, Eugenius Outerbridge. That project was followed by the completion of the George Washington Bridge between Manhattan and New Jersey three years later, and the Authority's reputation was enhanced by the fact that both bridges were finished ahead of schedule and under budget.

Although working hand-in-glove with government agencies in two states that traditionally had differing political views, the Authority also developed a reputation for political independence, and it was soon allowed to take over the operation of the already-opened Holland Tunnel, as well as to begin work on the Lincoln Tunnel—a two-decade-long project that wasn't open for business until 1937, at the height of the Great Depression. Although it floundered somewhat over those years, the Port Authority bounced back with the acquisition, in 1947, of Newark Airport in New Jersey, as well as LaGuardia and Idlewild (now JFK) airports in Queens. In the same year, it began work on the Port Authority Bus Terminal in midtown Manhattan and expansion of the already inadequate Lincoln Tunnel.

BELOW

In 1960, only twenty-nine years after it built the George Washington Bridge, the Port Authority doubled its capacity with a six-lane lower deck.

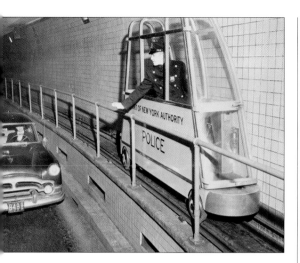

During its early years, the Port Authority contended with a similar organization called the Triborough Bridge and Tunnel Authority, the fiefdom of the master builder, Robert Moses. But in the early 1950s, it joined forces with Moses to construct the Verazzano Narrows Bridge between Staten Island and Brooklyn, as well as the Throgs Neck Bridge between Queens and the Bronx, and doubled the capacity of the George Washington Bridge by adding a lower deck. By then it had more than 9,000 employees and an annual budget of some $9.7 billion. It was clearly well-qualified to take on the job of planning the World Trade Center.

The Port Authority's 1961 report was accompanied by a detailed plan worked out by a board of architects that included Gordon Bunschaft of Skidmore, Owings, & Merrill, who had designed the seminal Lever House of Park Avenue. Their plan, which used the same East River site as the previous proposal, called for a five-story concourse topped by four buildings. The tallest of them, at seventy-two stories, was designated the World Commerce Exchange. The tower would house office and exposition space, as well as a 350-room hotel. The structure that was to be called the Trade Center was a thirty-story structure built on fifty-foot (15m) columns which would define the entry space for the complex. It would be joined by a thirty-story World Trade Mart, a modernist slab

LEFT

In 1954, the Port Authority introduced innovative electric patrol cars to the Holland Tunnel, replacing foot patrols that required its police to walk the tunnel's length to speed motorists on their way.

BELOW

In the 1940s, Parks Commissioner Robert Moses proposed a bridge cutting across Battery Park on its way to Brooklyn. A tunnel was eventually built instead.

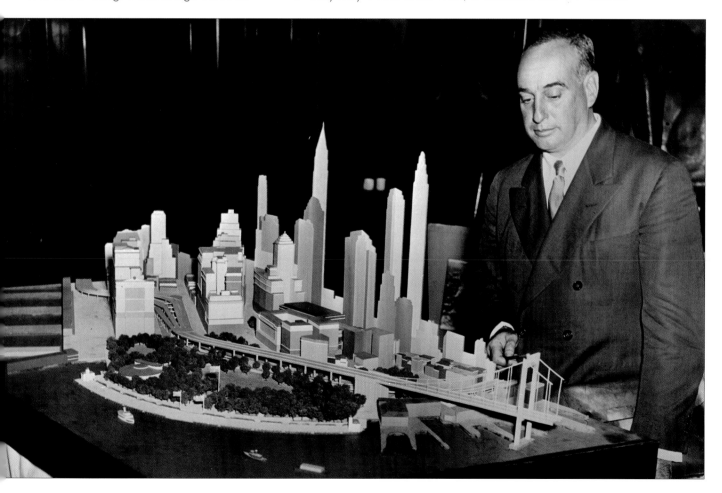

building like the other three, complemented with an eight-story pyramid-shaped building that would become the new home of the New York Stock Exchange.

The site was shifted to the West Side a year later. The Port Authority had in the meantime agreed to take over the operation of the bankrupt Hudson & Manhattan Railroad, a rapid transit line connecting New York and New Jersey. It was a move made necessary by reluctance on the part of the State of New Jersey to support the World Trade Center project, and its concern that the agency it co-sponsored with New York State was putting all its eggs into one basket for the primary benefit of New York City. The railroad's main terminal and office building, and twin office towers at 50 and 30 Church Street, were the largest office buildings in the world when they were built in 1908. They were major downtown landmarks, but more valuable now for the land under them that would become, in large part, the site of the new project.

BATTLE OF THE ARCHITECTURAL GIANTS

A new site called for a new plan, of course, and the Port Authority's commissioners didn't waste any time. A design competition was announced, and it attracted the cream of New York's architectural giants. It included, along with Gordon Bunschaft, Edward Durrell Stone, the architect of the General Motors Building across Fifth Avenue from the Plaza Hotel, and superstar Wallace K. Harrison. After distinguishing himself among the Associated Architects who designed the Rockeller Center, and then organizing the international group that built the United Nations Headquarters, Harrison's star rose even higher in the architectural firmament in 1958, when he put together a team of America's best architects to design the Lincoln Center for the Performing Arts. Among others invited to submit designs were Philip Johnson, who had worked with Mies Van der Rohe on the Seagram Building, and I.M. Pei, who would later design the Javits Convention Center further up the river. This project, as each of them saw it, would rival all the others as a centerpiece of New York's international dominance. But none of them was given the opportunity.

By the fall of 1962, less than eight months after officially becoming the Trade Center's developer, the Port Authority announced that the commission had gone to the relatively unknown design architect, Minoru Yamasaki, whose firm was located in the Detroit area. He would collaborate with the New York-based firm of Emery Roth & Sons, which had a solid reputation as a builder of office buildings.

Although none of his designs were finally accepted, Edward Durrell Stone was among the many prominent architects who submitted ideas for the Lincoln Center.

Lincoln Center's centerpiece, the Metropolitan Opera House, was designed by Wallace K. Harrison with the enthusiastic approval of William Schuman, the Center's president, and Met manager Rudolph Bing.

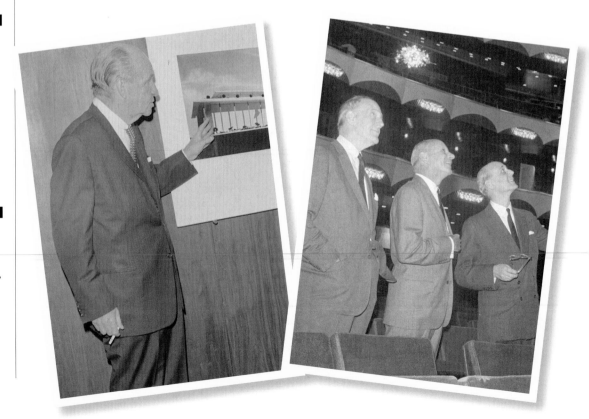

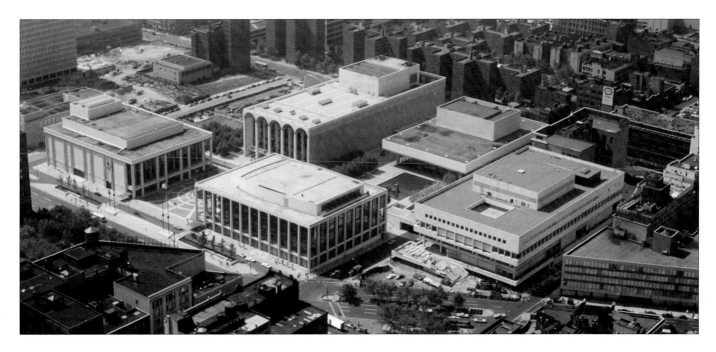

Yamasaki was the son of Japanese immigrants, born in Seattle, Washington, in 1912. His father was a maintenance man in a local shoe factory, and his mother a pianist. As he was growing up in the Pacific Northwest, he was forced to deal with ugly racism, which was compounded by his mother's insistence that he should wear bow ties at school every day. It made him a target of his all-American classmates, who viewed the formality as an effeminate affectation. He also suffered such indignities as being turned away from public swimming pools, and forced to sit in the back of the balcony when he went to the movies on Saturday afternoons. He seems to have taken it all in his stride, though, and he recalled in his biography that his father was vehemently opposed to letting the boy assimilate into the

Lincoln Center was completed in 1968, two years after the ground breaking for the World Trade Center.

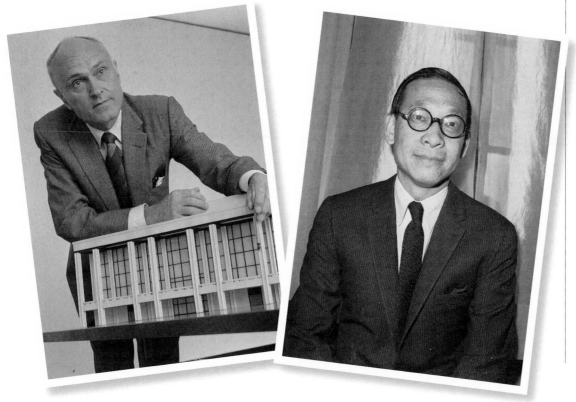

Philip Johnson designed the New York State Theater at Lincoln Center as well as the Fountain Plaza outside.

Ieoh Ming Pei, who worked on the original World Trade Center proposal, also designed the Jacob K. Javits Convention Center.

37

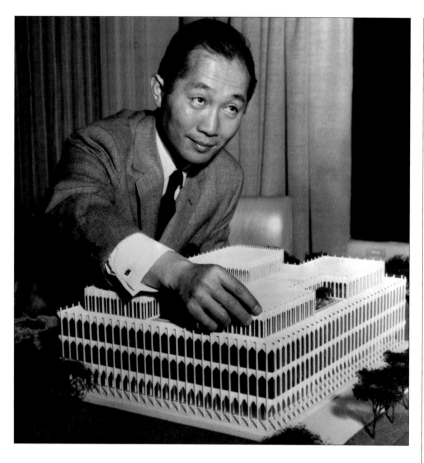

Before the World Trade Center, architect Minoru Yamasaki also designed the Education Center at Wayne State University in Detroit. His office was located at nearby Birmingham, Michigan.

design firm in Detroit, and in spite of the heightened anti-Japanese sentiments of the war years, he was eventually able to establish his own firm. No stranger to hard work, he built a solid reputation for himself, and in a few years he was affluent enough to relocate his firm in the upscale suburb of Birmingham, Michigan, where, ironically, he had been turned away when he tried to buy a house just a decade earlier.

His resumé appealed to Austin J. Tobin, the Port Authority's chairman, because he was far removed from the prima donna image most architects cultivated. He was also well-known for his record of sublimating his own ego and designing buildings exactly the way the client wanted them. Such self-effacement precisely matched the persona of the Port Authority itself. Its reputation had been built over the years by its commissioners' ability to rise above personalities and politics in the name of unselfish public service. It was also a plus that he had designed the award-winning Municipal Terminal at the St. Louis Airport, the kind of project a man like Austin Tobin could easily relate to.

Seen from that point of view, it should have come as no surprise that Yamasaki, a relative unknown in New York architectural circles, was given the job over a large field of contenders that included such superstars as Philip Johnson and I.M. Pei. But if his name wasn't a household word in New York, he had recently emerged into the architectural stratosphere with his highly acclaimed Federal Service Pavilion at the 1962 Seattle World's Fair. The contract to design the World Trade Center would, everyone hoped, keep him flying high.

Based on his earlier work, Ada Louise Huxtable, the architectural critic of *The New York Times*, was unstinting in her praise and approval of the PA's choice. The World Trade Center, as she believed Yamasaki would design it, would be, she wrote, "one of the loveliest buildings of our time." She went on to describe his style as, "experimental architecture [that] goes beyond contemporary standards to explore a more evocative world (Xanadu and Shalimar) for a broader, richer, and more ornamental contemporary architecture." She went on to conclude that, "One thing is certain: this large and important group of structures will be unlike anything that New York has ever seen before."

local culture, and anyway it gave him more time to concentrate on schoolwork.

College seemed out of the question for his struggling family, and, though he was willing to work for his tuition, he was turned away by prospective local employers because of his race. He solved the problem by going to Alaska, where he was able to earn the meagre salary of seventeen cents an hour working eighty-hour weeks in a fish cannery. It was tough, but good enough to allow him to enroll at the University of Washington, after which he moved to New York to earn his masters degree at New York University. He stayed in New York after graduation, and went to work in the offices of Shreve, Lamb, & Harmon, the architectural firm that designed the Empire State Building.

YAMASAKI'S CREDENTIALS

Yamasaki went on to serve a long apprenticeship with architect Wallace K. Harrison, followed by a position in the offices of Raymond Loewy, one of the country's top industrial designers. Ready for bigger and better things, Yamasaki took a job with a large

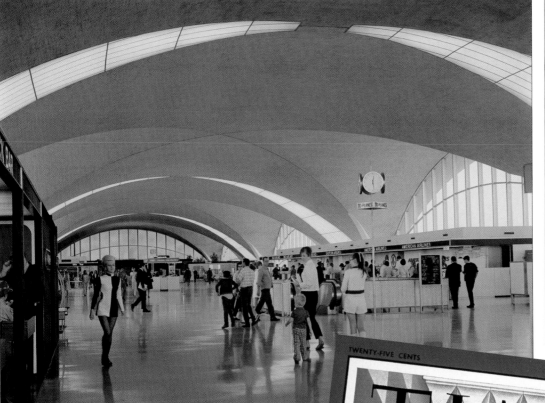

LEFT

Yamasaki's terminal building at the airport in St. Louis set new standards for airport construction around the world.

BELOW

The World Trade Center commission made Minoru Yamasaki a prominent national figure, and the subject of a Time magazine cover story in 1963.

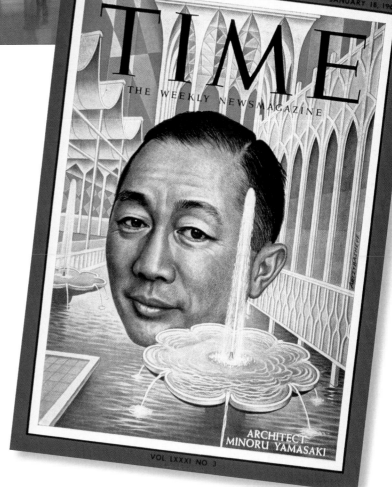

PUBLIC PROTEST

After accepting the commission, Yamasaki toured the site and was pleased to note that the existing buildings that needed to be demolished didn't seem to be worth saving. He wrote later that the blocks were filled with "radio and electronic shops in old structures, clothing stores, bars, and many other businesses that could be relocated without much anguish." He was only half right.

Even before the condemnation orders could be drafted, the owners of some of the stores in what was called "Radio Row" formed an organization they called the Downtown West Businessmen's Association, and like David confronting Goliath, they announced their intention to take on, and bring down, the Port Authority. The effort began with long and loud protests in the streets, but they didn't waste any time taking their case to court. Their suit challenged the constitutionality of any attempt on the part of the PA to force them to relocate. The argument was based on the fact that, as far as anyone could tell at that point, the new World Trade Center was really just an office complex, albeit one of gargantuan proportions,

In the 1930s, the east side of West Street, the future site of the World Trade Center, was a thriving little business community.

that had no firm commitment from any government agencies to relocate there. There was no "public good" to be gained by seizing the buildings of small businesses, they argued, and therefore the entire project should be either canceled or relocated itself.

The merchants dragged their case through the state courts, but the judges ruled against them every time. They finally took their argument to the Supreme Court of the United States, and in December, 1963, it upheld the lower court decisions. But among the opinions of the Justices, a statement that the issue didn't represent a federal question left the door ajar for the DWBA to pursue appeals in the lower courts. In every instance, judges ruled that their suit was nothing much more than a tactic to delay the condemnations. It finally came to rest when the Appellate Division of the New York State Supreme Court upheld the previous opinions that the primary purpose of the World Trade Center was to consolidate the efforts of governments around the world to conduct business in New York City. There was no doubt, in the opinion of the court, that this was clearly a project intended to further the interests of the American public. The effect of the decision was that work could now go forward on building the complex.

But the bulldozers hadn't arrived yet, and the store owners kept up their hopes that they could be headed off. Having exhausted all the legal avenues, they took to the streets again with loud protest demonstrations to alert the public to the fact that, in their opinion, the Port Authority was an uncaring organization with a well-honed "public be damned" attitude. A few months earlier, the State of New York announced that its downstate offices would relocate to the World Trade Center, which made it, indeed, a public building, and rendered the merchants' case moot. Still, they didn't give up. They countered with the argument that this was supposed to be a center of world trade and not a state office building. As far as they were concerned, it just represented a bit of political skulduggery on the part of New York Governor Nelson Rockefeller to support the dream of his brother, David. David Rockefeller had long been characterized as Public Enemy Number One by the association, but now they had found a new, and more visible, whipping boy.

The Governor had made himself more visible by running for President of the United States in 1964, and everywhere he went, in New York City at least, he was confronted with angry demonstrators waving picket signs portraying

The western blocks of both Cortlandt and Dey Streets were eventually "demapped" and elminated to clear the way for the Trade Center site.

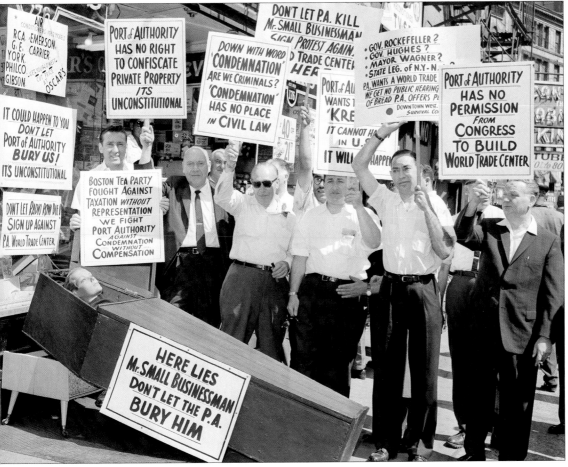

The blocks slated to be demolished for the Trade Center were known as "Radio Row" for their concentration of radio shops, such as this one on Greenwich Street, whose owners fought hard to stop the march of "progress."

him as an uncaring enemy of small business, not to mention everybody who had to work for a living. They may have won over many New Yorkers to their cause, and possibly even cost Rockefeller some votes, but their protests didn't have much more of an effect than to delay the Trade Center's progress for more than a year. The radio retailers ultimately relocated to Sixth Avenue above Forty-Second Street, where a building boom forced them out of yet another neighborhood. But they went quietly this time. For most of them, the fuel that had kept them in business was the sale of the host of different components for building high-fidelity audio equipment, and as manufacturers began providing self-contained units through less specialized stores, their businesses began to dry up. Only the most dedicated music lovers were still assembling tuners, tweeters, woofers, amplifiers, and pre-amps anymore.

POLITICAL PRESSURES

The Trade Center project wasn't out of the woods yet, though. There was another, more serious, problem threatening to derail the project, and this one was political. Because of its quasi-public nature, the Port Authority's properties are exempt from local taxes, and there was no precedent for a project like this one. Under David Rockefeller's original plan, the World Trade Center would have been a private enterprise, and potentially among the city's best sources of future revenue. But under the Port Authority's flag, it was no longer under the city's control. It not only faced an immense loss of potential income, but also of the legal oversight over the biggest office development within its boundaries.

Mayor Robert F. Wagner raised the first voice of protest in an interview with *The New York Times*, pointing out that the city was predicting a potential loss of many millions of dollars a year in tax revenue. He added that, "The city is not even in a position to turn the proposition down [and] must take it whether it wants it or not. We want to see the World Trade project succeed, but we must be in on the take-off as well as any crash landings." That reference was a nod to a part of the Port Authority's charter that allows it to make as much money as it can, but forces the local government to cover any losses from unsuccessful projects.

Chase president David Rockefeller put on a hard hat for his inspection tours of the Chase Manhattan Plaza construction.

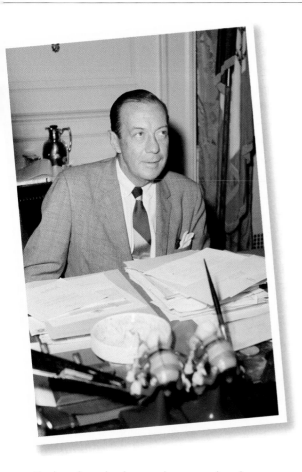

City Hall. He had a trump card to play that could help the city cut its losses. Although the Port Authority had the power to condemn property, even if that was still questionable, they were barred from reclaiming the city's streets, several of which would have to be de-mapped to assemble the superblock that the project demanded. Lindsay balked at allowing any deals, and instead called on the City Council to hold off its approval until public hearings could be undertaken.

During the Wagner years, the Port Authority had negotiated a deal to reimburse the city for lost income with annual payments in lieu of taxes. As the date for the public hearings came closer, the Authority unilaterally raised the figure from $1.7 million a year to a more generous four million. That managed to defuse Lindsay's scheme, but the hearings went on as scheduled, and it gave Port Authority Chairman Austin Tobin a way to explain the importance of the project in a bid to encourage public support. Traditionally the agency worked behind closed doors with only meagre details of its plans for various projects, and this one was no different. It was clear, though, that it

Mayor Robert F. Wagner fought to protect the city's interests in early Trade Center planning.

Mayor John V. Lindsay finally forced a public hearing to settle the debate on the city's role in clearing the way for the Trade Center.

Such a thing had never happened in the Authority's history, but there was still the possibility that it might. As an office complex, the Trade Center would be run by income from rents, and the commercial real estate market in New York is notorious for its tendency to fall dramatically from time to time. More important, such a huge development represented a drain of the city's resources in terms of fire and police protection, and transportation in and out of the lower West Side where systems would surely need to be upgraded.

There were also cries of "foul" from a group of state senators, one of whom pointed out that the city was being forced into the "surrender of sixteen blocks of the most valuable real estate in the world," and noted that, in his opinion, the complex was "nothing more than an ordinary office building operation that could be done privately." A State Supreme Court Justice chimed in with the opinion that the Port Authority had overstepped its mandate by assuming that the court's approval for demolishing the Hudson & Manhattan terminal gave it a go-ahead to condemn the rest of the neighborhood.

The controversy bubbled beneath the surface until after John V. Lindsay replaced Wagner at

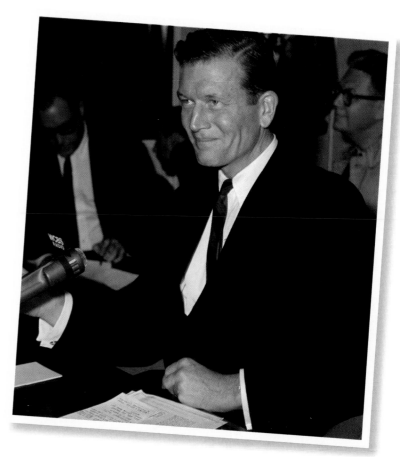

needed to come out into the open, at least enough to capture the public's enthusiasm, and the City Council hearings provided Tobin with a bully pulpit. He pulled out all the stops.

When he went to the City Council Chamber he took along an impressive assembly of blue star public officials, including the heads of nearly every chamber of commerce in the Port District, as well as Franklin D. Roosevelt, Jr., representing the federal commerce department. The list of those who came prepared to testify included John F. Kennedy, Jr., and cabinet members from the Secretary of State to the Secretary of Commerce. Although there was no television coverage, the press corps showed up in impressive numbers to help get the word out that something big was happening at City Hall.

For added emphasis, City Hall Park was packed with construction workers shouting demands for the work to get started. Building construction was in a serious slump at the time, and they let anybody who would listen know that their families and their way of life were in serious jeopardy. To reinforce their argument, the head of the building trades union told reporters that if the World Trade Center project didn't get started right away his members would go out on strike.

There were some people in that hearing chamber who came to present the other side of

the story. A group of some of the city's biggest real estate developers, including Harry B. Helmsley, testified that adding ten million square feet (929,000m²) of office space downtown would siphon off potential tenants from the Empire State Building, which Helmsley controlled. They also predicted that the general drift downtown would result in a drain of other buildings and turn midtown into a virtual ghost town. They had no hopes of being able to stop the building of the World Trade Center, but they believed they could force the Port Authority to pare down its size. The name of their consortium, The Committee for a Reasonable World Trade Center, said it all. Interestingly, these same developers were actively involved in assembling blocks of office buildings in the Trade Center neighborhood.

The PA countered by assembling its own phalanx of major developers, whose message to the City Council was that, rather than depressing the market, the Trade Center would actually have a major impact on the stability of Manhattan's office market. More important, in their view, was that it would guarantee the future of Lower Manhattan as the most important financial center in the world.

After the hearings ended, negotiations between the city and the Port Authority dragged on for yet another seven months, leaving the project still on hold. Tobin upped his offer of annual payments from four to six million dollars, and although Mayor Lindsay noted that the city could easily realize four times that much from a private developer, he accepted the deal anyway, and the last hurdle was cleared as the city authorized the condemnation of streets in the area and work could finally get under way.

The original budget for the Trade Center took a hit during the delay to the tune of $25 million a year in payments to waiting construction unions. Rising interest rates took an impressive toll as well, and by some estimates the Port Authority was forced to spend some $300 million more than it had planned. As far as the agency's public announcements went, though, it appeared that the project was going to be finished well within its anticipated budget.

Ground was broken at last on August 5, 1966—more than two years after the designs were first unveiled, and four years after planning began in earnest—and the official

Real estate mogul Harry B. Helmsley led opposition to the Trade Center. Years later, he and his wife, Leona, were arraigned in Federal Court on tax evasion charges.

ribbon-cutting for the complex took place on April 4, 1973. Some tenants had begun moving in, even though their employees had to snake their way around construction equipment, as early as 1970. From start to finish, the construction work took close to seven years, but in September, 2001, it disappeared in about half an hour after the terrorist attack.

MEETING THE CHALLENGE

The long stage wait wasn't all wasted time for Minoru Yamaski. The program he had originally been given by the Port Authority called for building twelve million square feet (1.1 million m²) of usable space on a sixteen-acre (6.5ha) site. He would also have to come up with a plan to accommodate the city subways and the PATH rail connection to New Jersey that ran deep underground into tubes under the Hudson River. The challenge was compounded by a relatively low budget of $500 million.

After studying models of more than a hundred different plans that might solve the problem, it was obvious that he needed to create a high-rise development. Among his first designs was a single 150-story tower, which he rejected early on because its scale would be oppressive.

From that moment, he opted to build shorter twin towers instead. He also rejected the possibility of building several smaller buildings on the site, because he believed it would take on the aspects of a high-rise housing development. When he first received the commission, he promised that the result would be "tremendous." He said that it would be a "beautiful solution of form and silhouette ... separate and apart from the rest of New York, with an identity of its own ... " His final design, which was unveiled early in 1964, seemed to fill the bill perfectly.

Where both earlier schemes proposed before he came on board had called for various-sized buildings rising above a podium, the new approach involved a much simpler solution. It would consist of two identical 1,350-foot (412m), 110-story towers rising above a five-acre plaza that would be surrounded by smaller office buildings as well as a hotel and exhibition space. These additions were seen as a means of reducing the visual impact of the towers themselves, which could be brutal without some softening

around the edges, but they were also useful as a means of shielding the towers from the impact of high winds blowing in from the Hudson River, which flowed past its doorstep on the west.

Most of the office towers that were built in Manhattan during the 1960s had the overall appearance of fragility in their curtain walls, but these towers would appear to be as solid as the older limestone structures. The effect was achieved by the aluminum cladding that was attached to the facade on steel structural ribs that were spaced only twenty-two inches

Before the Twin Towers became a reality, New Yorkers were given a preview with a giant-sized model of the wonders to come.

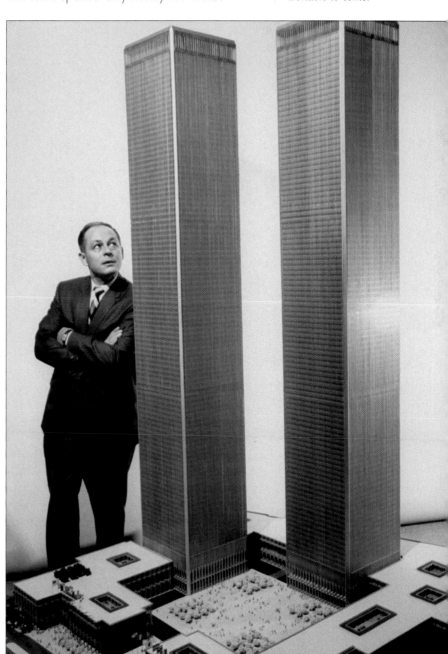

RIGHT

The pre-construction model of the Trade Center only hinted at the eventual massiveness of the complex, but it was a glimpse of a future that everyone knew would be exciting.

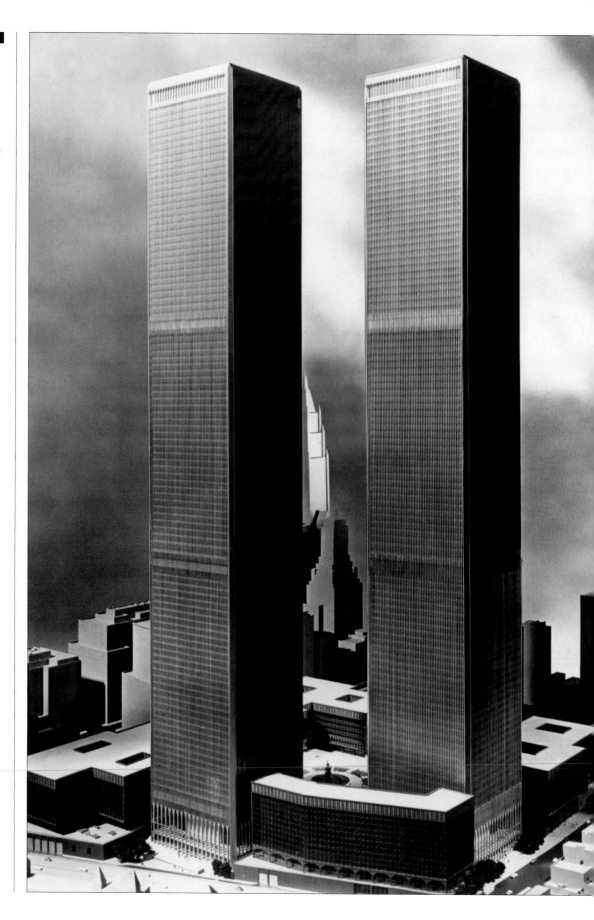

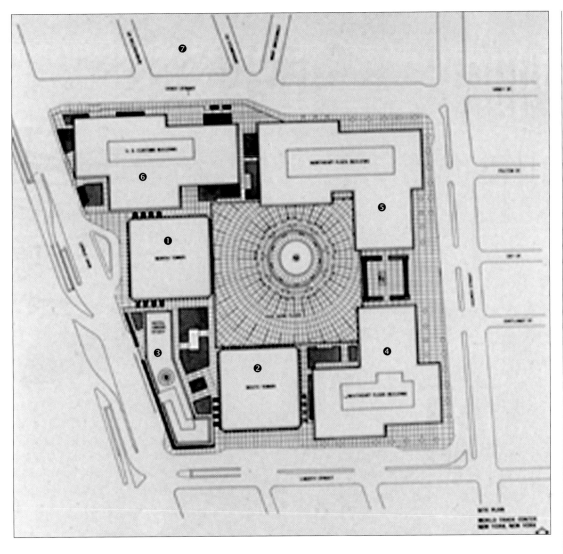

LEFT

The plan of the complex seemed to involve more ground space, but the site, amazingly, covered only sixteen acres (6.5ha).

❶ *WTC – North Tower (110 floors)*
❷ *WTC – South Tower (110 floors)*
❸ *WTC – Hotel (22 floors)*
❹ *WTC – South Plaza Building (9 floors)*
❺ *WTC – North Plaza Building (9 floors)*
❻ *WTC – US Customs House*
❼ *WTC (47 Floors)*

(56cm) apart, reducing the amount of glass by more than thirty percent. The overall effect was like the slits in the walls of castles, just wide enough for a defender to fire arrows at an enemy, but too narrow for missiles to get inside. Seen from a distance, the effect was that the buildings didn't have any windows at all, and from inside they were regarded as an antidote to attacks of acrophobia among the people who would work there. Toward the base of the towers, the space separating the structural members was doubled, and lower floors and lobby areas were crowned with metal tracery reminiscent of the Doge's Palace in Venice. The lobbies themselves were seven stories high, with the third level serving as a mezzanine along the outer perimeter that overlooked the lobby itself. The window treatment also widened by a third above the 107th floor to take advantage of the

spectacular views, with an observation deck in one of the towers and an upscale restaurant on the top of the other. The exterior's decorative motif was repeated at the tops of the towers as well, but they themselves rose into the sky in a disarmingly simple, clean unbroken line.

MAXIMIZING SPACE

Among the problems Yamasaki had to deal with was getting the maximum usable floor space behind those exterior walls. In the end, he managed to make the Trade Center towers seventy-five percent efficient, as builders label the amount of actual rentable space. Most office towers are considered successful when the efficiency percentage reaches fifty-two.

This so-called unusable space is taken up mostly by elevator shafts. The innovation that made this one different was the dividing of the towers into three separate zones, with elevators

The structural system of the Twin Towers, using a closely knit steel frame to support the exterior walls, was a daring concept when it was proposed, but it had a precedent—the IBM Building in Seattle.

accessed through what Yamasaki called "Sky Lobbies" on the forty-first and seventy-second floors that were connected to the ground floor by high-speed express elevators. Passengers bound for higher floors switched from them to another bank of elevators, which made local stops on the floors above because the shafts that served the upper floors didn't have to extend all the way down to ground level, dramatically reducing the number of elevator shafts running from bottom to top. The plan made it possible to increase the usable space by twenty-five percent over comparable buildings. It included twenty-three express elevators and seventy-two local elevators in each of the three zones, far fewer than in towers that were dwarfed by this one.

Yamasaki's solution made it possible to give the buildings enough room to accommodate office space for 50,000 people, and to comfortably serve the needs of an additional 80,000 daily visitors. Along with setting a new record as the world's tallest buildings, in terms of space the Twin Towers were the biggest office buildings on earth. They were three times bigger than the Pentagon in Washington, the record-holder for a generation, and double the occupancy potential of the Metropolitan Life Tower rising above Grand Central Terminal. The official figure was ten million square feet (929,000m²) of rentable space, two million less than the original challenge the Port Authority had given its architect, but still impressive by any standards.

Before the official opening, two million square feet (186,000m²) of the space had been committed to the State of New York and the New York City government, and there was solid interest on the part of international trade organizations for another four million square feet (372,000m²). But first they had to get those towers built.

A MIRACLE OF ENGINEERING

Along with his own staff of fourteen architects, Yamasaki worked hand-in-glove with the engineers, John Skilling and Leslie Robertson, of Worthington, Skilling, Helle, and Jackson. Faced with the problems inherent in building such tall buildings, they decided to innovate a whole new way of doing things. The IBM Building in Seattle was their inspiration for the model they adapted in the form of a unique hollow tube of closely-spaced steel columns,

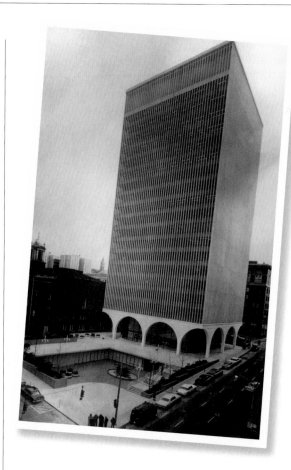

with floor trusses running across to the central core. Except for the elevator shafts and service core, there were no other obstructions between the outer walls.

Because these towers were the first skyscrapers ever built without load-bearing masonry, Skilling and Robertson were faced with the possibility that vibrations caused by the high-speed elevators might intensify the air pressure and cause the shafts to buckle over time. Rather than conventional elevator shafts, they came up with a completely new system incorporating drywall construction anchored to a core of reinforced steel.

Their hollow tube system allowed them to build unusually light, and very economical, structures. The 280-foot-wide (85m) facades were actually a lattice of steel beams spaced thirty-nine inches (99cm) apart, which provided effective wind bracing on the outside rather than on the interior, where the central core supported only gravity loads. The individual thin concrete floors were supported by steel trusses, each extending sixty feet (18m) to the core, and functioning as a means of stiffening the exterior walls and making them immune to possible buckling from excessive wind pressure.

Before this system was put into place, curtainwall buildings, which became the norm after the 1950s, relied on bracing in the interior.

The engineers also incorporated a sophisticated telecommunications system, which was America's first to have data and video available through a fiber-optic and cable network that allowed electronic international mail and other business services to be received instantaneously. Although such things are relatively common these days, it was a major breakthrough at the time, and the system broke new ground for everything that followed.

Other statistics that never have been topped include delivery of enough electricity, 60,000 kilowatt hours of electricity every day, to serve the needs of a city of 400,000 people. Its airconditioning system handled 400,000 tons of air each day, too—more than enough to supply every refrigerator in a city with a population of a million.

GETTING OFF THE GROUND

Before construction could actually begin, a small army of workers assembled to demolish the buildings that were already on the site. The

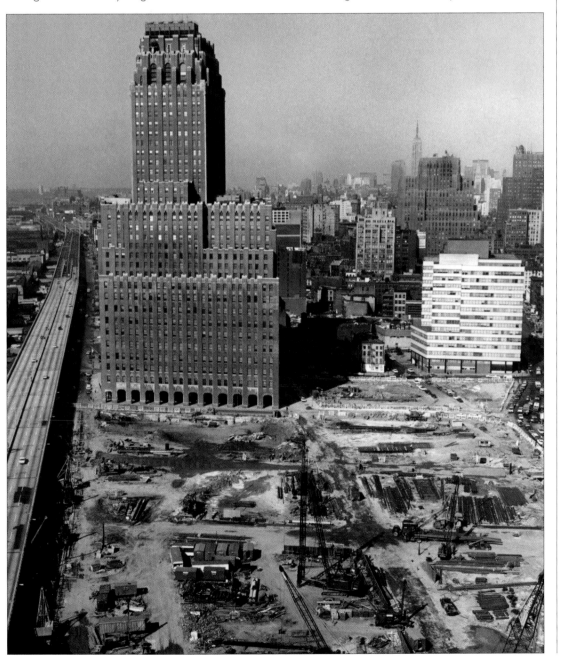

When the Trade Center site was finally cleared, workers at the New York Telephone Company in the Barclay-Vesey Building had a different, if temporary, view of the blocks to the south.

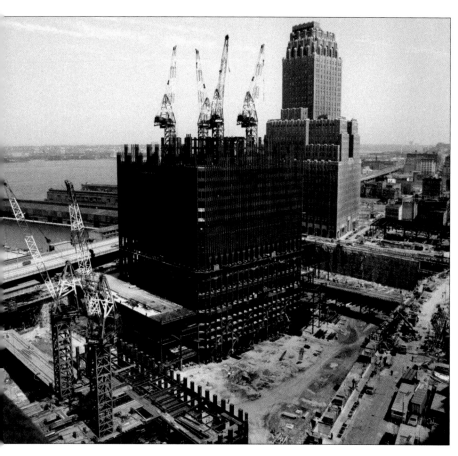

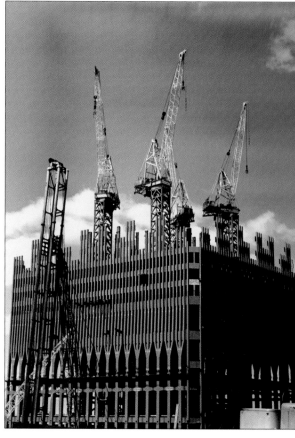

ABOVE

The steel skeleton of the Trade Center was anchored to bedrock far below street level at the bottom of the pit that would become the largest shopping mall in Manhattan.

ABOVE RIGHT

The cranes that hoisted the steel skeleton into place were developed by the Port Authority just for these buildings.

RIGHT

As the North Tower rose, its twin wasn't far behind, and their aluminum skin was already being fastened into place.

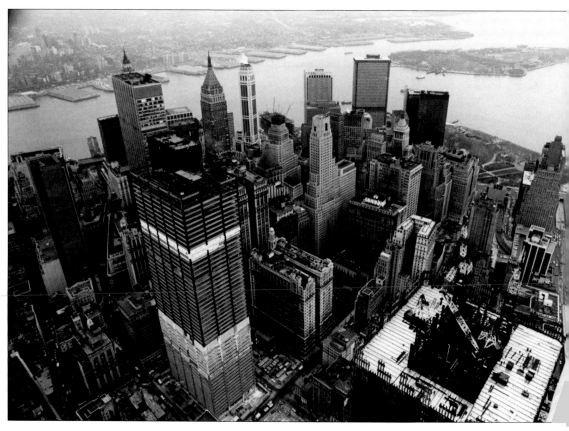

debris was dumped into the Hudson River, beginning what would become the biggest landfill in the city's history, even dwarfing the tons of dirt and rocks that had to be disposed of when the subways were built sixty years earlier.

The next step, which the Port Authority's flacks characterized as "miraculous," took advantage of an experimental technique that had been developed to build the subway system in Milan. It involved pouring a three-foot-thick (0.9m) concrete wall seventy feet (21m) below the surface, where it was attached to the bedrock with steel cables for more than a thousand feet (305m) around the rim of the site. Its major purpose was to hold back the waters of the Hudson River as well as the subsoil around the perimeter. Once the wall was in place, excavators began removing the earth and thousands of long-buried artifacts that had accumulated there over more than three-hundred years. As foundation work began, the engineers faced a delicate problem in shoring up the old cast-iron tunnels of the Hudson and Manhattan Railroad. Their work was so successful that the trains kept running all though the project with no disruption in service

and no inconvenience to passengers, many of whom would eventually work in these buildings.

Once the huge pit was finished, heavy steel plates were anchored to the bedrock, the first step in building the Trade Center's foundation, and after the concrete floor was added, the buildings were ready to rise. But before that, the towers' subcellars needed to be developed. Even before the towers themselves were completed, this huge multilevel underground space, all but a secret to most outsiders, was ready to go into action. It would contain an ammunition dump for the Secret Service, a precinct for the Port Authority Police, complete with jail cells, and the emergency nerve center of the New York City Police Commissioner. The space also contained a telephone switching station capable of handling millions of lines, space for the Federal Aviation Administration links that connect the activities of the three local airports, electrical generators capable of serving the entire complex in case of emergency, and the central computer system for monitoring the environment in the building above. All this more than forty feet (12m) below the concourse level.

BELOW

The North Tower was first to reach its full height. Workers gazing west from up there looked down on the Hudson River landfill, the site of their next major source of jobs.

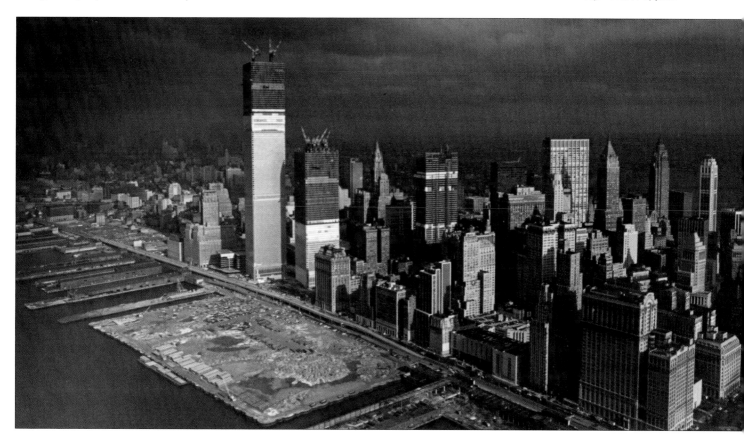

By the end of 1970, as work progressed, the Woolworth Building, once the world's tallest, seemed tiny compared to its new neighbors. So did the rest of Lower Manhattan. The building in the lower foreground is the mansard-roofed 90 West Street by Cass Gilbert, the Woolworth Building's architect.

When spring arrived in 1971, the Twin Towers had already established themselves on the downtown skyline and New Yorkers had already become accustomed to their looming presence.

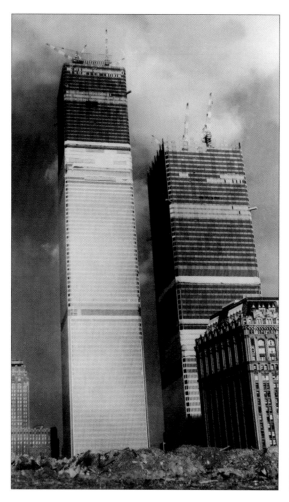

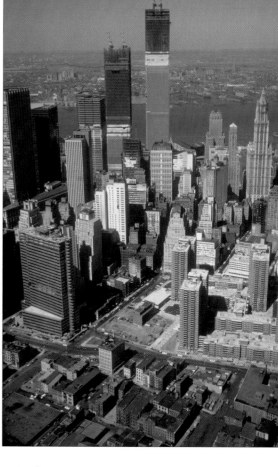

The steel beams for all of New York's previous skyscrapers had been hoisted from the street by three-legged derricks that were themselves hauled up and re-assembled as each floor was completed. For this project, the Port Authority developed a special type of hydraulic crane that was capable of lifting itself up floor by floor in far less time. The cranes, which have since become standard in all high-rise construction, cantilevered out over the edge, prompting the construction workers who used them to christen them "jumping kangaroos." A common sight in New York these days, the 200-ton cranes "jump" upward when assembly is completed at the level where they stood, and raised up thirty feet (9m) higher by hydraulic jacks. When the structure is finished, each crane dismantles the one next to it and lowers it a piece at a time back down to street level. When only one is left up there, it hauls up the pieces of an old fashioned derrick, which is used to lower it down to the street. Then the derrick is itself dismantled and sent back down

in the freight elevator. The saving in time would have amazed nineteenth-century skyscraper builders, and the resulting saving in money warms the hearts of modern-day contractors.

Once the towers began rising from the ground, more than four-thousand construction workers were assembled on the site every working day, and their activities needed to be coordinated in much the same way as a circus ringmaster makes sure that every act comes on and goes off on a tight schedule. When the Empire State Building was built, there was no room on the surrounding streets to store construction materials, and all the steel, prefabricated at the mill, had to arrive at the precise moment it was needed. The beams were quickly hauled up to the top of the rising frame and the truck that brought them then drove off to make room for the next load. The process became standard operating procedure for all high-rise construction from that time, and all the players knew very well what was expected of them.

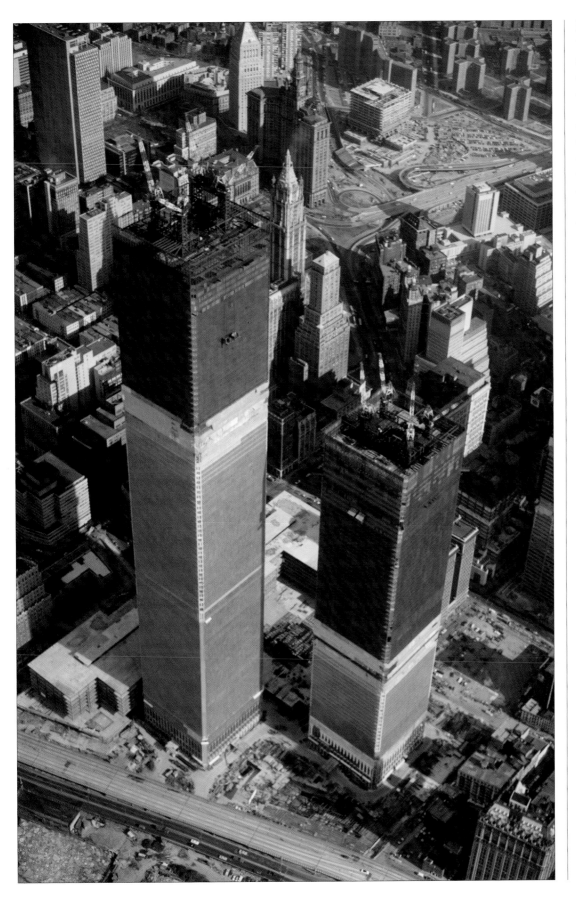

The open space behind the nearly completed South Tower would become the huge Austin Tobin Plaza, and the space in the foreground along West Street would be the site of the elegant Vista International Hotel, which later became the Marriott Hotel.

RIGHT

The North Tower was the first to be topped out. The Hudson River piers to the north of the landfill would eventually be covered as part of even more new real estate.

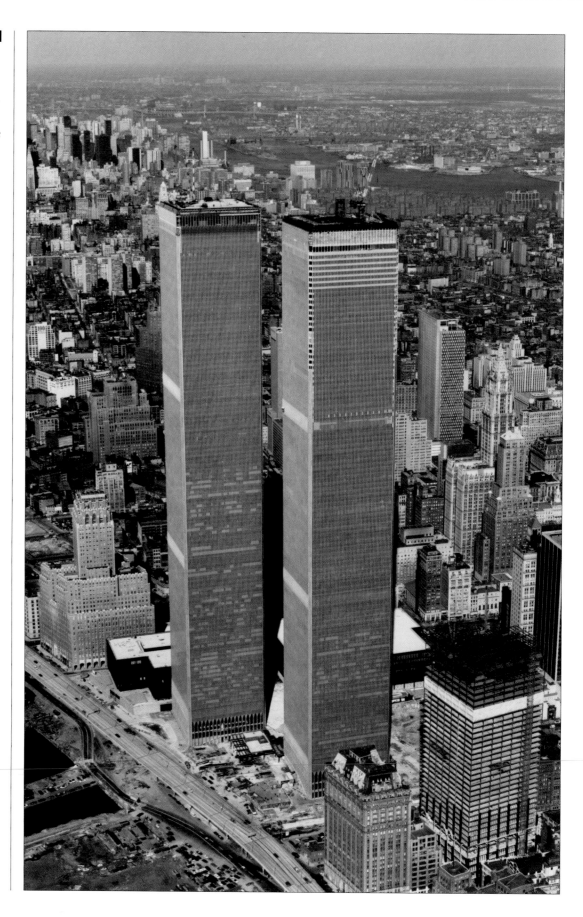

Every person involved in building a skyscraper like the Trade Center towers, from steel mill workers to teamsters to iron workers, steamfitters, plumbers, and electricians, needs to be working within a strict time schedule as closely determined as the dimensions of the steel beams that are fabricated miles away and put together like pieces of a puzzle on the site. If one beam or section of conduit arrives to the job even an hour late, the whole project may be forced to shut down. It came close to happening during one short period of Trade Center construction when drivers went out on strike, threatening to tie up steel deliveries, which would have caused such a shutdown. But the Port Authority had anticipated the action, and after securing agreements from the other trades to cross the Teamster picket lines, rounded up a fleet of heavy-duty cargo helicopters to fly the steel across the Hudson right on schedule. The choppers were brought over from Australia to augment the work of the jumping kangaroo cranes on top of the superstructure.

By long-standing tradition, when a building's steel frame is completed, or "topped-out," the structural iron workers raise an American flag above the highest point as a signal that they had gone as far as they had been hired to go. In the case of the Twin Towers, the flag was raised at the end of each week, as though there was no limit to what was happening here. Times columnist Russell Baker noted that the buildings "seem to go on and on endlessly in the upward dimension, as though being constructed by battalions of exuberantly unstoppable madmen determined to keep building until the architect decides what kind of top he wants."

The men who built the Trade Center were justifiably proud of what they were accomplishing down there near the foot of Manhattan, but all was not sweetness and light on the job site. Dozens of unexplained fires broke out while work was continuing on the buildings, and several bombs went off, including one that completely destroyed the headquarters of the Tishman Construction Company, the general contractor hired by the Port Authority to actually build the project. It was presumed to be the work of out-of-sorts subcontractors, but there were still plenty of Trade Center detractors out there.

THE PUBLIC REACTION

In the years when bankers and businessmen were reaching for the sky with their buildings, the public generally reacted with excited anticipation. It was an era when "sidewalk superintendents," ordinary citizens with a fascination for big-time construction, watched closely as foundations were dug, steel beams hoisted into place, and finishing touches applied to the skyline. But when Yamasaki's plan was first announced, most New Yorkers just yawned. Those who did respond were usually negative, complaining that the last thing the city needed was another ugly box rising above its skyline. Others, whose aesthetic

The official dedication of the World Trade Center, on April 4, 1973, included welcoming words from New York's Governor, Nelson A. Rockefeller. The ceremonies were held in the lobby of the North Tower.

sensibilities weren't offended, complained about the size of the buildings, which they believed would have a negative effect on what they perceived to be the human scale of downtown Manhattan. Many people who had watched the infighting that delayed the project kept up the drumbeat by arguing that these buildings were nothing less than a real estate swindle on the part of the Port Authority to make millions at the expense of the taxpayers. The biggest concern, though, seemed to be an uneasy feeling that the new towers would intrude on the low-rise character of the district along the river. That concern was summed up by a group of architecture students at City College, who wrote a letter to the editor of *Architectural Forum* magazine which expressed concern that these new towers would be totally out of place and would drive "... the whole of Manhattan ... into a different scale and ruin what is now one of the most exciting spatial arrangements in the world. If the Chase-Manhattan building can be challenged for the destruction of Wall Street's consistency, then the twin towers will add the final touches to this fatal feat."

The influential critic, Ada Louise Huxtable, who had been so warm in her praise of Yamasaki's entry into the project, seems to have had a different view of his creation. The

architect, she wrote, "... has developed a curiously unsettling style, which involves decorative traceries of exotic extraction applied over the structure or built into it. His choice of delicate detail on massive construction as a means of reconciling modern structural scale to the human scale of the viewer is often more disturbing than reassuring. ... Here we have the world's daintiest architecture for the world's biggest building."

All of these, and other, objections were raised before ground was broken, and although some editorialists had begun calling for a change in the announced plan, it was already too late. In the long years between the plan's acceptance and the beginning of actual construction, Yamasaki's designs hardly changed at all since they had left the drawing board. He modified his original plan to build a hotel and exhibition space as a continuous unit along the site's western edge by designing four separate buildings facing West Street to harmonize with new buildings already being planned across the way. But the Twin Towers would be built as originally announced, no matter who objected.

After they were actually built, critic Huxtable fired off an even more damning assessment. "The towers are pure technology," she wrote, "the lobbies are pure schmalz, and the impact

The Twin Towers made other skyscrapers seem insignificant, but strollers in the plaza between them took it all in their stride. It was an unusual experience, to be sure, but this is New York, after all, where all experiences are heady ones compared to those in lesser cities.

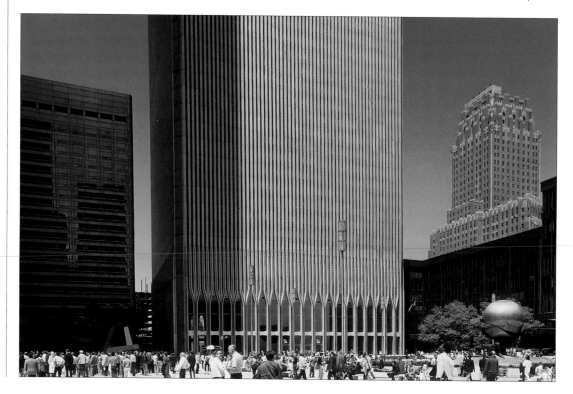

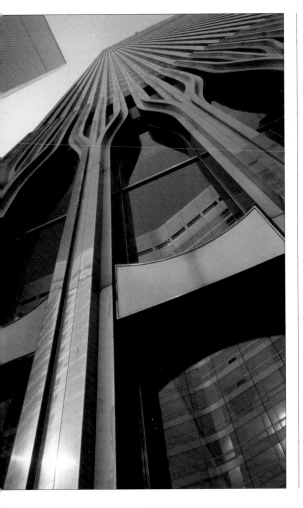

on New York ... pure speculation. In spite of their size, the towers emphasize an almost miniature module ... and the twenty-two-inch-wide [56cm] windows [are] so narrow that one of the miraculous benefits of the tall building, the panoramic view out, is destroyed. ... These are big buildings, but they are not great buildings. The grill-like metal facade stripes are curiously without scale. They taper into the more widely-spaced 'Gothic trees,' at the lower stories, a detail that does not express structure [so much as] tart it up. The Port Authority has built the ultimate Disneyland fairytale block-buster. It is General Motors Gothic."

Yamasaki had already dismissed the critic's opinion and defended his work by saying that, "I was trained in the twenties and early thirties, when Classic design was the theme of the day. Though the traditional historic architectures I was taught then are not appropriate to our present-day techniques of building, their graceful proportions are still vital to any structure." Otherwise, the architect kept his own reaction to criticism to himself. But during a press conference at the Trade Center dedication, a reporter asked why he had built two 110-story towers when the new techniques would easily have allowed him to build a single one rising up to 220 stories.. "I didn't want to lose the human scale," he quipped.

LEFT

The wider windows at ground level brought natural light into the tower lobbies, but they narrowed as the buildings rose to accommodate the unique steel framing that opened office areas into virtually column-free spaces.

LEFT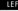

The overall effect of the design of the Twin Towers was that they were buildings without windows. But, though narrow and set back, they did provide panoramic views for the people inside, and allowed daylight to stream into their offices.

3 The Life

Seven years after work was begun, the Twin Towers were finally ready. Although most observers were impressed by the accomplishment, there were still naysayers, especially among the press, which began firing off new negative salvos. Among them, New Yorker critic Lewis Mumford labeled the buildings as examples of "purposeless gigantism and technological exhibitionism."

RIGHT

The East Coast Memorial in Battery Park contains the names of 4,596 merchant mariners lost during World War II, fewer than were the victims of the Trade Center tragedy.

FAR RIGHT

The Trade Center lobbies often featured exhibitions, but were never more beautiful than at Christmastime.

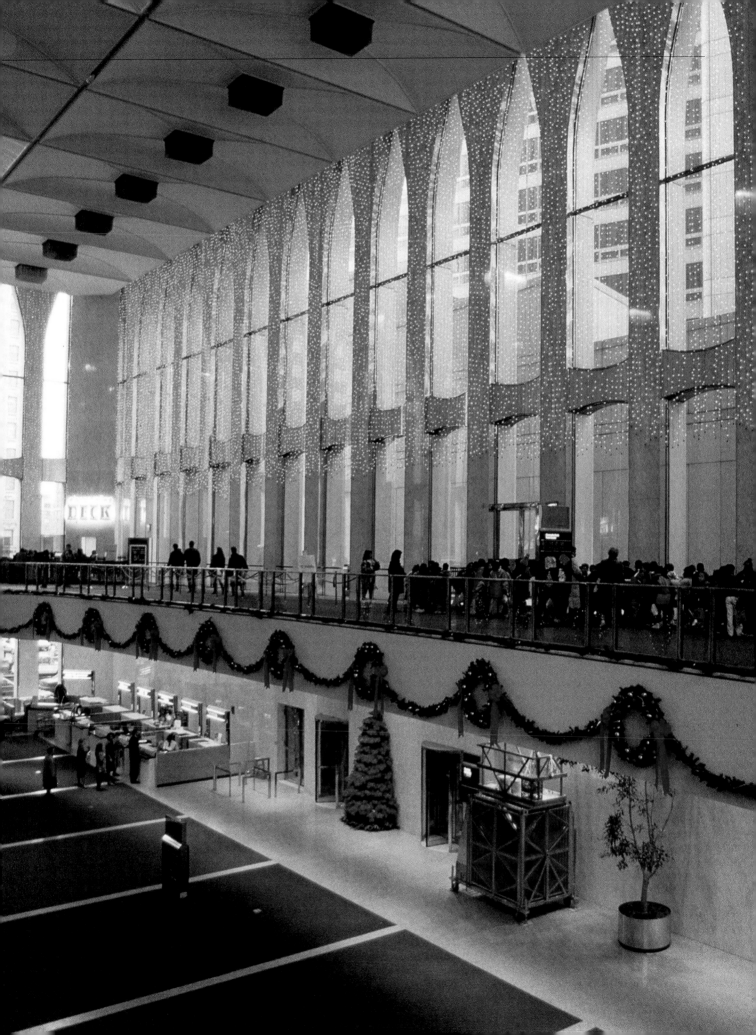

The public was inclined to be more kind in its general assessment of the newly opened World Trade Center. After all, like the eight-hundred-pound gorilla that wanders into your house, there isn't much you can do about it.

ATTRACTING PUBLICITY

These buildings were going to take some getting used to, but the problem for the moment seemed to be translating all that bulk into human terms. The first step literally fell from the sky in the person of a publicity-seeker who parachuted from a plane and made a perfect landing in the center of the roof of Tower Number Two. Within a few days, another skydiver leaped from the top of Tower One

On May 26, 1977, workers arrived at the office late as they watched mountain climber George Willig scale the walls of their building.

and made a safe landing in Austin Tobin Plaza 1,350 feet (411.5m) straight down.

Alone, these two daredevils might not have turned the trick of humanizing the Twin Towers. But in 1977 toymaker and amateur mountain climber George Willig accomplished it by scaling the side of Tower One as thousands of spectators watched, heart-in-throat, from the plaza beneath. He was immediately arrested for trespassing after he climbed over the edge of the roof, and right behind the police officers who had been waiting up there all morning for the climb to finish was a gaggle of Port Authority lawyers with fire in their eyes. They had a summons for Willig demanding that he go straight to court and pay the fullest possible fine for violating the Authority's private property. The judge who heard his case had a twinkle in his eye, and possibly remembering the controversy over whether the Twin Towers were public or private property, set the fine at one cent a foot for the distance the perpetrator had climbed. Then, after carefully counting out the $1.35 and handing it over to his clerk, the judge shooed Willig off with a stern warning not to try the same stunt on Tower Number Two.

The Port Authority should have paid him. At their most creative, the PA's public relations men couldn't have come up with a better way to call attention to their new towers, nor to demonstrate that they were people-friendly after all.

Three years earlier, in the summer of 1974, another daredevil had put the Twin Towers on the front pages, when a tightrope-walker named Philippe Petite walked between their tops on a slender steel wire. He had put the wire in place by firing a crossbow across the void, and once it was fastened for him on the other side and made appropriately tight, he began casually walking the 131 feet (40m) across the empty space far above the plaza. The stroll took forty-five minutes, but that was because Petite stopped every now and then to wave to the crowd below and to entertain them with the usual tightrope tricks such as flexing his knees and walking backwards. The accomplishment drew awed praise from the press, which once again rubbed off on the towers themselves, but (unlike for Willig in 1997) there was no hue and cry from the Port Authority's offices downstairs to throw the book at him.

When asked why he did such a thing, Petite responded, "If I see two oranges I have to juggle, and if I see two towers I have to walk."

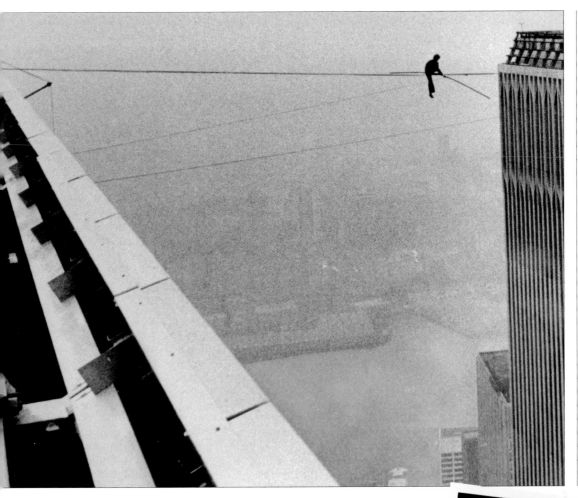

LEFT

LEFT

In 1974, Philippe Petite walked between the Twin Towers on a tightrope 1,350 feet (411.5m) up in the air, pausing now and then for a stunt or two.

BELOW LEFT

Petite is still walking tightropes in unlikely places. He is currently an artist-in-residence at the Cathedral of St. John the Divine.

BELOW

When the movie King Kong was remade, the scene was shifted to the World Trade Center, where the beast came crashing down into its plaza. The picture itself crashed at the box office.

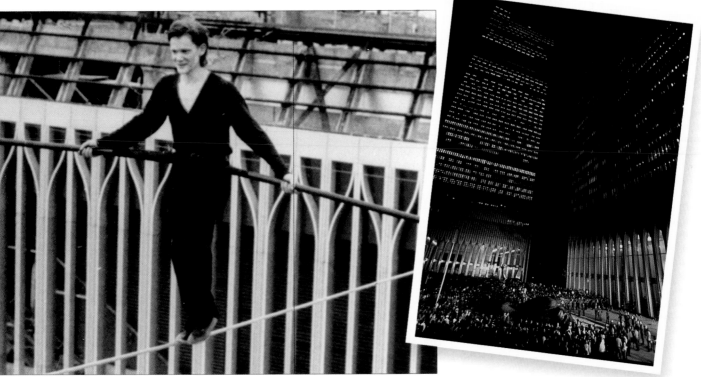

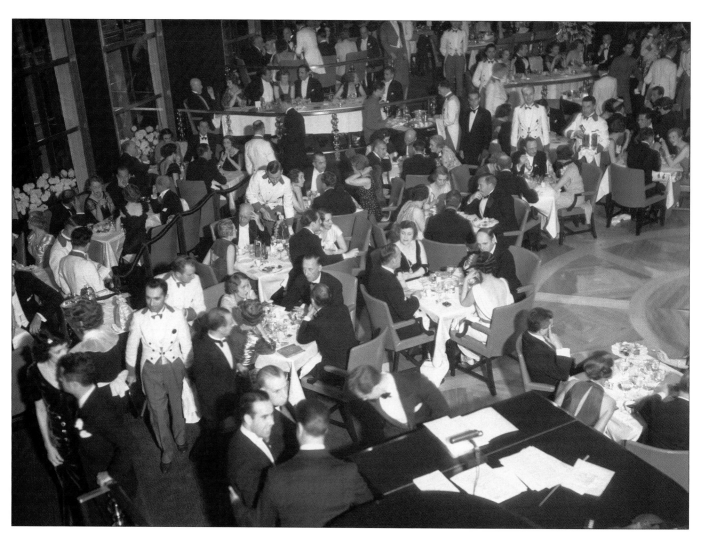

ABOVE

After the Rainbow Room opened on the 65th floor of the Rockefeller Center's RCA building in 1934, it set the standard for all tower dining spaces. It was considered the most elegant dining and dancing spot in the city for decades.

VIEWING THE WORLD

Even without the efforts of a couple of stuntmen, New Yorkers would probably eventually have come around to the idea of making the trip downtown to see for themselves what a billion dollars and millions of hours of hard work had accomplished. They were, after all, the world's tallest buildings, and the world's biggest inside as well, and things like that are mother's milk to the heart of the average New Yorker. It wasn't important that so many of them found the towers ugly and intrusive—they had to be seen just because they were there. And then there was that view.

The view from the top of the Twin Towers could be experienced in one of two ways: from the Observation Deck on the South Tower or from the elegant restaurant, Windows on the World, across the way on the north building.

It was common practice to put observation decks on the tops of the tallest buildings almost

from the start. The Singer Tower was the first to do it, with an open-air observatory just below its bulbous crown, but the building's owner, the Singer Sewing Machine Company, closed it after a year or two because of the appalling rate of suicides it attracted. That didn't dissuade the designer of the Woolworth Building, who added a more enclosed, but still open, sightseeing deck to share the view with those unfortunates who didn't work for F.W. Woolworth.

Naturally, the Chrysler Building had an observation deck, complete with a little museum containing the tools Walter Chrysler used when he began building cars by hand. The building's crown also housed the Cloud Club, a private facility for executives working in the building. Rockefeller Center's RCA Building was more egalitarian with its top floor restaurant, the Rainbow Room, although it also had a private club up there for power lunches

Among the visitors to the Empire State Building in 1954 was England's "Queen Mum," Elizabeth, who was met at the top by Richard C. Patterson, New York City's official greeter, and former building president, William Keary.

The Empire State's Observatories are on the 86th and 102nd floors, the latter 1,250 feet (381m) above the sidewalk. The Trade Center's Observation Deck was 100 feet (30.5m) higher.

among well-heeled executives. Its observation deck was on the same level as the restaurant below the building's crown on a south-facing open-air setback, which had stadium-style bleachers stacked against the far wall. Its view of the Empire State Building was the best in the city, but the view looking back was even better.

The Empire State's Observatories are on the 86th and 102nd floors, with the former open to the sky, and its views are in all four directions. Of all the observatories on New York skyscrapers, this one, which is also open until midnight for prime-time viewing, has the most fortuitous location. Looking north into midtown, the view almost encourages you to reach out and touch beauties like the Chrysler Building, and if you happened to have a Frisbee handy, and could toss it over the arching fence that surrounds the deck, it seems as though it might easily reach the middle of the Great Lawn in Central Park from up there.

The Trade Center's Observation Deck was in the North Tower. Its view included the other tower, with a huge television transmitting mast on its roof.

For those who wanted an extra thrill, a raised platform over the Observation Deck added stiff breezes to the enhanced view.

Though further removed from the center of the action, the World Trade Center Observation Deck overlooked a 360-degree panorama, too, but while the harbor views were dramatic, the most interesting one was the northern exposure that revealed the rest of Manhattan in all its glory. In fact, as one cynic noted in the early days of its existence, the best thing about going up there was that you could see Manhattan without the Twin Towers getting in your way. The Trade Center's Observation Deck was completely enclosed with diagrams on the windows that matched the view so that visitors knew exactly what they were looking at. For those who preferred their views au naturel, a short escalator ride led to a deck rising above the tower's roof. This was no place for the faint of heart—the only way back down was another escalator on the far side of the platform, and once up there it wasn't possible to turn around and go right back. The deck was reached by high-speed express elevators, large enough to carry a compact car, that took less than a minute to get from the

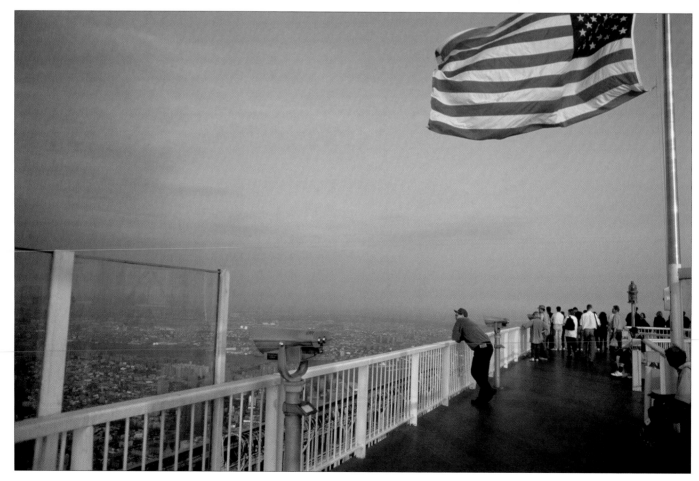

Among the events at the top of the Trade Center was a 1995 chess match between Russian Gary Kasparov and Viswanathan Anand of India. Kasparov won and kept his Professional Chess Association title.

The view through the windows of the Observation Deck was not only all of Manhattan, but of the harbor below and New Jersey beyond, as well as east to Long Island and north far up the Hudson River.

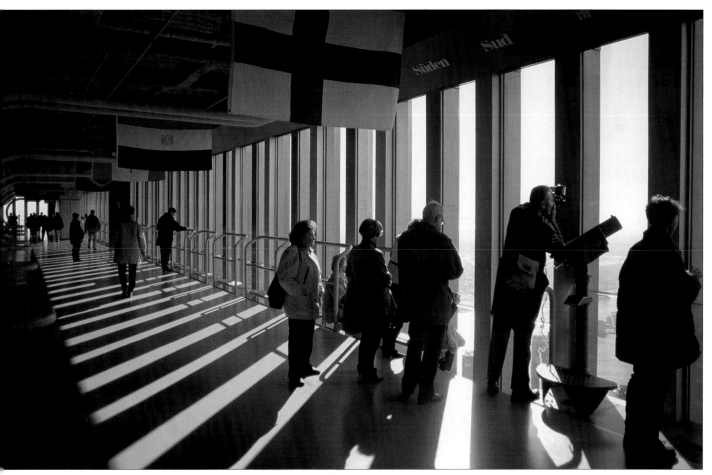

One of the best things about New York is its sunsets, and the best place to appreciate them was while dining at the Windows on the World restaurant.

Every table at Windows on the World guaranteed a view, thanks to a terraced arrangement. The elegance was enhanced with brass, marble, light-colored woods, and soft beige fabrics.

lobby to the 107th floor. Appropriately, the word "Welcome" was emblazoned on the elevator walls in eighteen different languages.

HAUTE CUISINE

In 1976, even the most jaded New Yorkers who typically shun such tourist attractions began lining up for the elevator ride to the top of a World Trade Center tower. The new attraction was Windows on the World, a posh restaurant on the 107th floor of the North Tower. At the time it opened, the city was going through another of its periodic financial declines, and nothing in the world could have done more to change the mood—as well as, finally, the general public view of the Trade Center complex—as this unexpected touch of elegance. Among the restaurant's biggest boosters, *New York Magazine*'s food critic Gael Greene gushed that this place was so wonderful that "... even New Jersey looks good from here." She thought the food was worth the trip, too, if only it were possible to get a reservation.

The restaurant was conceived by the innovative restaurateur Joseph Baum, who had already dramatically changed America's concept of "white tablecloth" restaurants and the services they provided. The space, which was often compared to an elegant ocean liner, also included banquet rooms and the "Cellar in

Though not as elegant as Windows on the World, there was a dining experience awaiting visitors to the top of the other tower. A snack bar serving New York-style food guaranteed that no one went away hungry.

the Sky," one of the best wine cellars anywhere in the United States. It was designed by Warren Platner, who conceived it as a series of terraced levels rising back from the outer windows so that every patron was assured a table with a view, even if it did happen to be of New Jersey.

More than any other single thing, Windows on the World altered the average New Yorker's opinion of the World Trade Center, transforming indifference and even outright hatred to benign respect at the very least. All it took was a little glamour.

Ironically, the restaurant had originally been planned as a private club for the executives of tenant companies, but when word began leaking that the Port Authority had budgeted $6 million to build a facility that would be closed to the public, the grumbling could be heard in every corner of the port. A compromise changed the policy to allow the restaurant to be open to everyone during the evening hours, but entry would still be restricted during the lunch hour.

At the other end, in every sense of the word, there were scores of fast food restaurants down below street level on the concourse in what was called the Mall at the World Trade Center. With some 427,000 square feet (39,670m²) of retail space, it was a serious rival to many large suburban shopping malls. Among its

tenants were Gap, J. Crew, Banana Republic, and The Limited along with book stores, drug stores, and other businesses including banks and brokerage offices, which added to the convenience of working on the floors above— over the store as it were. The central portion of the mall, designed to emulate a town square, was a bank of escalators leading downward, seemingly forever, to the PATH station far below for commuter service to points in New Jersey. Several lines of the city's subway system served the Trade Center through stations located on the same level as the mall, and for those who

Most of the complex's population and visitors arrived by subway through stations on the concourse level, or by PATH trains running below it.

The sculpture in the Austin J. Tobin Plaza, appropriately named Globe, by Fritz Koenig, slowly revolved above the central fountain.

Austin J. Tobin Plaza, among the largest in the city, was intended to evoke Plaza San Marco in Venice. The Gothic arcade formed by the surrounding buildings was vaguely reminiscent of the Doge's Palace at the edge of the original.

preferred to drive to work, there was a parking garage adjacent to it that was big enough to accommodate 2,000 cars. No matter how anyone chose to arrive, everyone entered the tower lobbies, and the other Trade Center buildings as well, at the concourse level without a worry about the weather outside.

LOW LIFE

For the most part, it is safe to assume that the vast majority of the people who worked in the Trade Center, or visited there, came and went through the underground concourse, which was also connected to the pair of bridges over West Street that led to the World Financial Center, dramatically adding to the pedestrian traffic, especially during the rush hours leading up to nine in the morning, and following the established end of the work day at five in the afternoon.

It was possible to enter the towers directly from the street, of course, but in order to do so, it was necessary to negotiate a path around

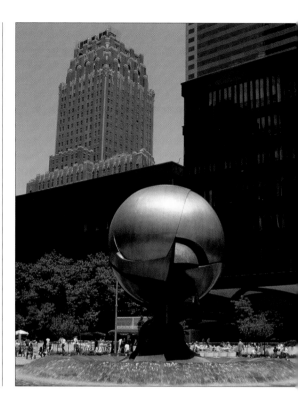

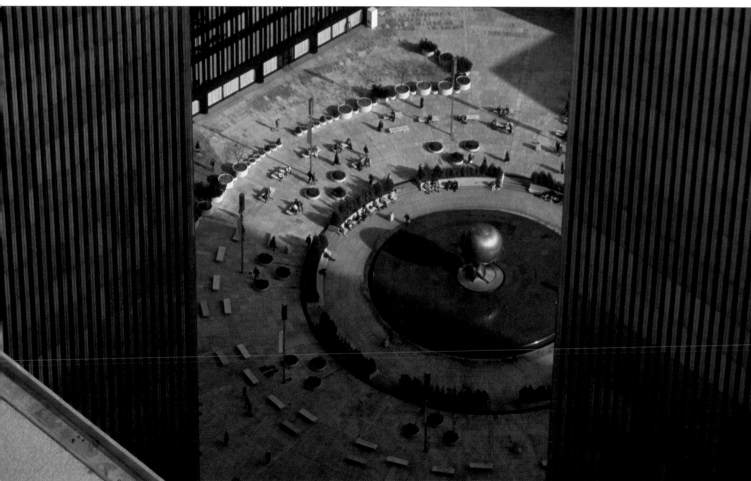

the sculptures, the central fountain, an ice skating rink, and strollers out for a little fresh air and possibly a quick smoke—a pleasure denied them anywhere inside the buildings or the concourse. Conceived as New York's answer to the St. Mark's Square in Venice, the open space, named Austin J. Tobin Plaza in honor of the Port Authority Director, was often compared to the Twin Towers themselves and characterized as a third tower, although it rose only a few feet from the ground. The open space it created between the two buildings was equal to the footprint of the individual towers.

The Trade Center lobbies were decorated with original work by some of America's best contemporary artists, but the most visible original art was in the form of the sculptures in the outdoor spaces. All of them were monumental, but necessarily so because of the massive scale of the setting. The sculpture in the center of the plaza was the bronze broken-surfaced Globe by Fritz Koenig. Symbolizing the international focus of the complex, it was mounted over a large fountain where it revolved slowly above the splashing water. Between the towers themselves was a work by James Rosati called Ideogram, made of polished stainless steel, twenty-four feet (7.3m) high and twenty-eight feet (8.5m) long. The largest free-standing stone carving in modern

times, a highly polished asymmetrical work in black granite by Masayuki Nagare, stood guard over the plaza's main entrance. Among other works in various places around the perimeter was Three Red Wings, a 25-ton stabile by Alexander Calder.

OTHER BUILDINGS

The building known as 3WTC was opened in 1981 as a twenty-three-story, 825-room hotel. Designed by Skidmore, Owings, & Merrill, it was the first hotel of any size built near the Financial District, and followed the lead of the original East Side World Trade Center scheme suggested by the Downtown Lower Manhattan Association. It was named the "Vista," and, indeed, it did offer rare harbor views which included, in some cases, a window on the Statue of Liberty. Originally owned and operated by Hilton International, which also eventually took over the operation of Windows on the World, the property was bought by the Port Authority for $78 million in 1989 and completely renovated three years later at a cost of $28.5 million. It was sold again and became a Marriott Hotel in 1996.

Seven WTC, standing across Vesey Street, slightly to the north of the self-contained Trade Center complex, was built in 1987 on land owned by the Port Authority as a speculative

The plaza was a handy place, a quick elevator ride down, for speedy lunches, freeing up the rest of the lunch hour for shopping down below or at the discount department store across the street.

The black granite sculpture at the entrance, by Masayuki Nagare, was said to have been the largest free-standing stone carving in modern times. Like other outdoor sculpture in the complex, it needed to be massive to match the setting.

ABOVE

Real estate developer Larry A. Silverstein took control of the entire World Trade Center complex in July, 2001 through a $3.2 billion deal, resulting in a 99-year lease. He has said that he will rebuild on the site, and incorporate a memorial to the Trade Center victims. At the time he made the promise, it was estimated that cleanup would take at least two years and rebuilding another five.

venture by developer Larry Silverstein. There didn't seem to be much risk involved as the 47-story glass and red granite building began to rise. It was intended to be the headquarters for the investment firm of Drexel Burnham Lambert, which had promised to invest some $3 billion for the privilege of having a World Trade Center address. But before the company could begin enjoying the benefits of its new address, the bottom fell out of the junk bond market, Drexel's most important business, taking down the savings and loan institutions that had invested heavily in the bonds, on Drexel's advice. The company went out of business three years later. Among the tenants that helped fill the resulting void was the City of New York itself. Some of the space at 7WTC was converted into a bunker for use by the mayor and his key commissioners to keep the city running normally after a disaster such as a hurricane. The idea was soundly ridiculed when Mayor Rudolph Giuliani announced its establishment, but it did offer a safe place with up-to-the-minute communications facilities not available in any other city government location. It also had the advantage of being located a short distance from City Hall and, besides, the rent to the city in this theoretically public building was relatively cheap. As it turned out, the bombproof bunker was located in exactly the wrong place when the city was faced with

the greatest disaster in its history.

For architecture buffs, the greatest disaster of the second half of the twentieth century was the moving of the US Customs Service into 6WTC in 1973. The federal government, which owned its old home on Bowling Green, declared the building redundant and it appeared that its days were numbered. It was eventually saved when the Smithsonian's Museum of the American Indian took over the space, but the solution was a long time coming, and for a while the predictions that it would have to be demolished put preservationists in a state of panic. It would have meant losing one of the world's greatest examples of nineteenth-century beaux-arts architecture because the institution it had served was relocated to a rather banal box at the edge of the World Trade Center.

But the Customs Service wasn't the only institution to relocate there. In 1974, the various commodities exchanges moved across town to a new location that brought them under one roof for the first time in the history of their existence. That roof was over 4WTC, a nine-story building also known as South Plaza. It was the result of an offer nobody could refuse. In exchange for relocating, the Port Authority made the space available to them at the unprecedented rate of three dollars a square foot, compared to the bargain price of nine dollars that the State of New York was paying for its space. The exchanges stayed there for more than twenty years, but in the 1990s they announced that they were moving again, this time over to New Jersey, taking more than 5,000 employees with them. As usually happens in the wake of such announcements, the city fathers scrambled to put together an incentive package that would encourage them to stay. It added up to almost $100 million. Ironically, the city and state governments had already paid $184 million toward the cost of building a new commodities exchange in nearby Battery Park City, and in the face of the new incentives the exchange's commissioners decided to move into it. Their threat to move across the river ended with a move across the street. The new rent they would pay there came to a million dollars a year, which to most of us would seem ridiculously high, until the actual market rate is taken into account. That would have been somewhere in the neighborhood of $18 million.

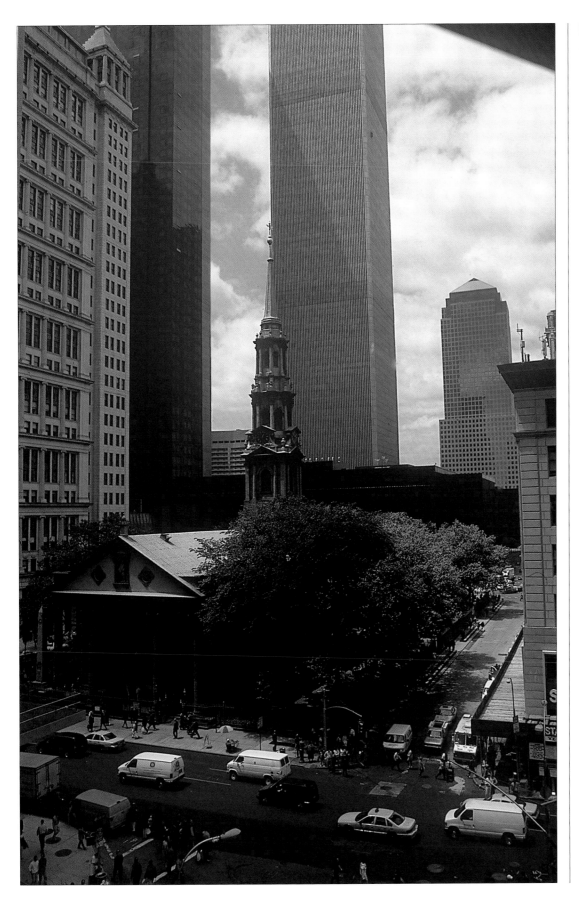

Although it altered the skyline, the Trade Center didn't change the Manhattan streetscape, except to attract more taxicabs (but not at five in the afternoon or on rainy days, of course), private cars, and delivery trucks. As a native New Yorker would say, "So, what else is new?"

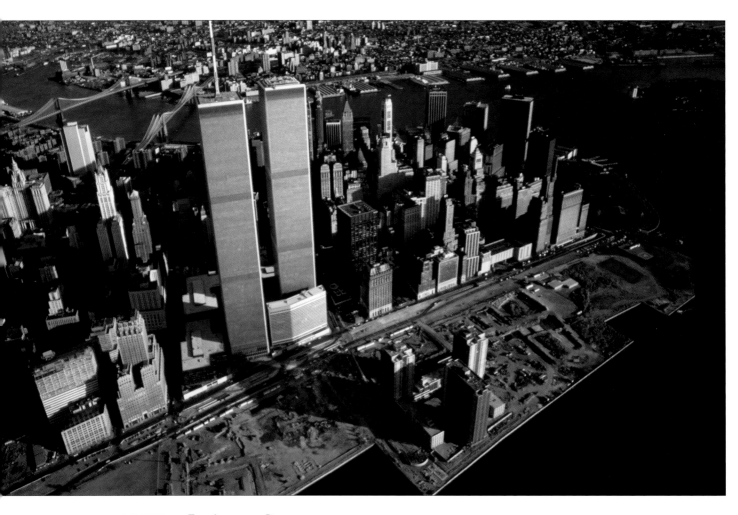

The Manhattan skyline is forever changing, but by 1982 it seemed there was no more space to fill. Except for that landfill over there. In another five years, the World Financial Center would be there.

THE LANDFILL DEVELOPMENTS

The debris hauled out of the World Trade Center site was conveniently dumped into the Hudson River, creating almost one hundred acres (40ha) of new land that promised to give Lower Manhattan some badly needed breathing space. The fill also acted as a kind of urban renewal in itself. The riverfront was lined with rotting piers that had been abandoned when ocean-going freight started arriving aboard container ships that were too big for the old-fashioned docking spaces in Manhattan. Once the ships began loading and unloading in Brooklyn and across the way in New Jersey, the piers and warehouses that had served them and a host of ferry lines in earlier years were boarded up and forgotten. There was no life there, and without adding housing there was no chance of any life anywhere in lower Manhattan after five o'clock in the afternoon. Vitality could only come by transforming the area into a twenty-four-hour neighborhood, a problem that seemed to defy solution.

Finding available land in New York had always been a problem, and the density of downtown had been slowing growth for several generations. The only way a new building could be built was to tear an old one down. The skyscraper itself provided the best solution, allowing the city to grow upward when there was no room to spread outward. But below City Hall, there was no space to go in either direction. The landfill provided a perfect answer, an opportunity to create America's biggest planned urban development project, which would be called Battery Park City.

The first step toward making Lower Manhattan attractive, and legal in the face of zoning laws, as a place to live came with a study and a report by the Downtown-Lower Manhattan Association. This was a group of businessmen and interested citizens that merged with, and replaced, the older association formed by David Rockefeller. Its master plan, released in 1958, suggested, among other things, rezoning the entire downtown area to prevent

manufacturing facilities from operating anywhere but in a triangular-shaped neighborhood bounded by Canal and Cortlandt Streets west of Church Street, which would much later become known as Tribeca (the triangle below Canal Street). Manufacturing had historically been a cornerstone of Manhattan's economy, but after World War II the factory facilities started moving out, either to the suburbs or the other boroughs, leaving

behind big open loft spaces. In spite of the DLMA's attempt to consolidate the operations of those who chose to stay, by zoning them into a single part of the area, it meant that many of these small businesses would have to move there from other neighborhoods. Most of them chose to move out of Manhattan altogether, abandoning even more lofts.

The result was the transformation of Tribeca into a residential area, as artists and others who were looking for large spaces with small rents began moving down from SoHo into the lofts. It established a precedent for downtown living, and even created a demand for it. There was no reason why it shouldn't. The transportation facilities in the area were already the best in all of New York City. And for a time at least, the rents were lower than in neighborhoods that had already been developed.

But the plan to build on the new land at the edge of the Hudson languished for years. The initial announcement that something was about to happen over there came from Governor Nelson Rockefeller in 1966, and it was quite specific about what the State intended to do with the land that was being handed over. The "coordinated community" that the governor described would extend north from Battery Park to Chambers Street, and would include a mix

By the early 1970s, small manufacturers had abandoned their sites in the neighborhood called Tribeca. In no time at all yuppies filled the vacuum, as the former factory spaces were converted into expensive loft apartments.

After service as the Trade Center's leading cheerleader, Governor Nelson A. Rockefeller turned his attention to Battery Park City, plans for which he unveiled at a press conferece in 1966.

Mayor Ed Koch found inspiration in Battery Park City. Never missing a chance to enhance his role as the city's number one booster, it was a kind of golden opportunity.

of middle- and lower-income rental apartments as well as schools and other public facilities. The private sector would finance the creation of more than eight million square feet (743,000m²) of new office space in the midst of it all, Rockefeller promised. It would, he pointed out, help finance the project, which would otherwise have to be financed with public funds.

Not much more happened until two years later, when the governor and Mayor John Lindsay jointly announced the formation of the Battery Park City Authority, a quasi-public agency with bonding capability, that would finally get the project rolling. The announcement was accompanied by a new plan that reduced the commercial space by some three million square feet (280,000m²), and layered market-rate apartments over the previously-proposed middle- and lower-income units. The architecture was changed as well, but because of a soft real estate market, it was decided to put the office development on hold but to go ahead with the housing. Still, it took until 1974, another six years, for work to actually begin, and after all those years of planning and counter-planning, what seemed to be emerging was a collection of undistinguished drab brick middle-income housing units, hardly distinguishable from the brutal housing projects

that had sprung up in every corner of the city to no one's satisfaction, not even the poor tenants. The city's own fiscal problems of the 1970s slowed the project even more, and finally admitting defeat, it leased the acreage to the Battery Park City Authority, a move that took the city out of the loop in implementing any development plans. Under a deal hammered out by Mayor Ed Koch and Governor Hugh Carey, the state would condemn the landfill and then take over the job of developing it. Ownership would revert back to the city at some undetermined point far off in the future

As people began calling Lower Manhattan home, it started taking on the aspects of a village. Ignoring the buildings around it, some of them even turned to Battery Park for their weekend soccer games.

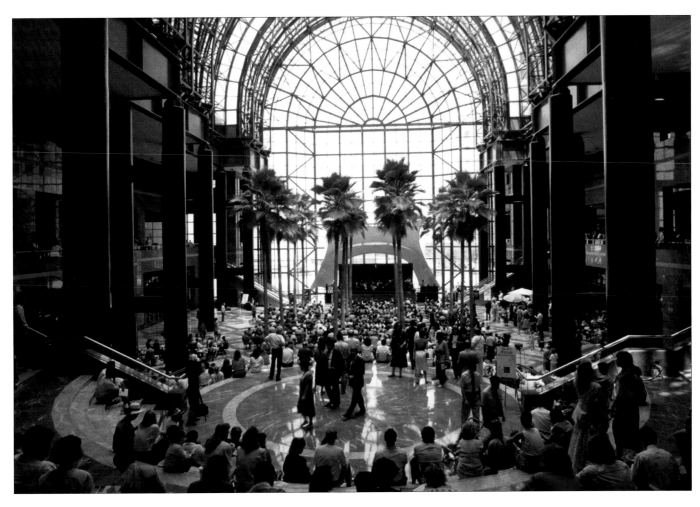

when the cost of development had been recovered. The State then proceeded to revise the development plans one more time, and this time around the concept of anything but market-rate apartments had fallen by the wayside, prompting some critics to begin calling Battery Park City "The Riviera on The Hudson."

Meanwhile, the landfill, which everyone began calling "the beach," sat empty and unused except for occasional art exhibitions, including the work of one creative person who put down a couple of acres of topsoil and planted a wheat field on it. This piece of art was symbolic, she explained, of the relationship of the city to the country. It also demonstrated to New Yorkers who strolled along the river's edge in the shadow of the Twin Towers that they had a clean slate to work with here.

NEIGHBORING COMPLEX

Construction, real this time, began in 1974 on Gateway Plaza, a residential complex. The plan, as it existed by that point, called for using forty-two percent of the land for housing, thirty percent for open space, including the esplanade running along the river, nineteen percent for streets and avenues, and the rest, nine percent, for commercial and office space.

The contract for developing that portion of the project went to Canadian-based Olympia and York, which proposed a World Financial Center that would be connected to the World Trade Center on the other side of West Street by a pair of pedestrian bridges. The walkways would also lead symbolically to Wall Street. The eventual plan by Cesar Pelli Associates produced four office towers between thirty-three and fifty-one stories high, as well as two octagon-shaped nine-story structures. The complex includes a generous outdoor plaza and a marina big enough to berth twenty-six ocean-going yachts. Directly behind it is the glass enclosed Winter Garden, whose 130-foot (40m) barrel-vaulted ceiling shelters sixteen giant palm trees flanking a wide marble-paved public space frequently used for musical

The World Financial Center's Winter Garden, with space the size of Grand Central Terminal's main concourse, is often the scene of concerts and other cultural events. The 90-foot (27.5m) palms are Washington robusta, *one of the hardiest of a very large botanical family.*

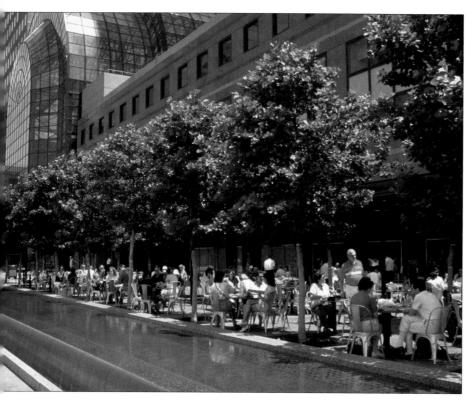

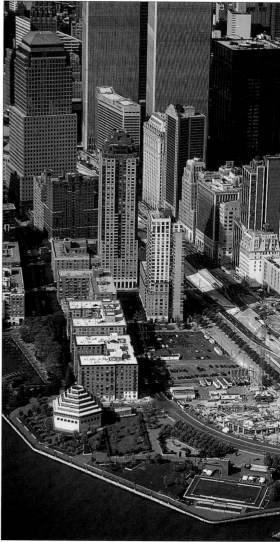

The World Financial Center's outdoor plaza overlooks its huge marina and the river beyond. It is edged with polished granite cascading pools.

The Museum of Jewish Heritage, at the downtown end of the Esplanade, was built in 1996 to designs by Kevin Roche, John Dinkeloo & Associates. The Museum actually opened in 1997.

The 1.2-mile Battery Park City Esplanade runs along the river's edge into a series of parks extending north to Chambers Street.

entertainment. The connected buildings also have shops and restaurants at ground level, adding to the shopping and dining opportunities that were available to workers at the World Trade Center. Alongside the marina, known as North Cove, is a memorial to all New York City police officers who have died in the line of duty, and whose names are carved into its granite face.

Tenants like American Express and Dow Jones, Merrill Lynch and Oppenheimer, all of whom have located their world headquarters there, help bring the daily working population of the World Financial Center up to numbers in the neighborhood of 35,000. The number of people who live there is more than 25,000. Both numbers were growing dramatically through the 1990s, and still don't show any signs of stopping.

The complex extends northward along the riverbank up to the edge of Tribeca, where it is anchored by Stuyvesant High School, one of New York City's most prestigious, built in 1992 at Chambers Street. Immediately below the school is the seven-acre (2.8ha) Governor Nelson Rockefeller Park, opened in 1992 at the northern end of the 1.2-mile-long esplanade that extends down to Battery Park. Every step of the way is enlivened by changing

landscaping and a series of mini parks. It ends at the pyramid-shaped Museum of Jewish Heritage, built in 1996, just above Battery Park, where a stroller can keep going all the way around to the East River. Future plans, already in the process of being implemented, will open the riverfront to walkers, joggers, and bicyclists all the way up through Riverside Park above Seventy-Second Street and then on uptown as far as the George Washington Bridge.

In the stretch along the Battery Park City esplanade, the residential opportunities range from the almost quaint developments toward the south, designed to echo such uptown neighborhoods as Gramercy Park, to townhouse developments, high-rises, and the thirty-four-story towers of Gateway Plaza, home to 1,700 families.

The overall effect of Battery Park City and the World Financial Center was to soften the massive impact of the Twin Towers, but it might not have worked out that way if the original early schemes had been followed. All of them were conceived as fairly massive blocks of buildings that would have turned their backs on the rest of downtown, but the final solution, a master plan by Cooper-Eckstut Associates, reoriented the space to blend with the neighborhood to its east and in that way become part of it. The existing east-west streets were extended into the area without a break in continuity and the new north-south avenues were oriented to Manhattan's street grid above Houston Street. Rather than isolating itself from the rest of the city, as almost happened, Battery Park City became a welcome extension of it.

THE ELDERLY NEIGHBOR

The Twin Towers also had an older neighbor that seemed terribly out of place, but it was still a reminder of what this part of the city had been like before the march of progress overtook the area. It was St. Nicholas Greek Orthodox Church, a tiny whitewashed wooden structure only fifty-six feet (17m) long and twenty feet (6m) wide, that stood in the shadow of the South Tower surrounded on three sides by parking lots. The church, whose congregation hadn't included more than eighty souls for as long as anyone could remember, had been standing on that spot since 1912, and it had resisted the growth of the financial district around it, even though its tiny plot of

ground had increased in value by tens of millions of dollars. Its namesake, St. Nicholas, is the patron saint of New York and, coincidentally, of bankers and brokers, and there are those who believe it was his intercession that steeled the parish to stay put in the face of promises of riches beyond their wildest dreams if they would only agree to relocate somewhere else. They held on right up until September 11, 2001, when its neighbor across the street came crashing down on the tiny church and destroyed it.

The Trade Center's oldest neighbor was the tiny St. Nicholas Greek Orthodox Church, whose cross-topped belfry was as significant a local landmark as the towers themselves.

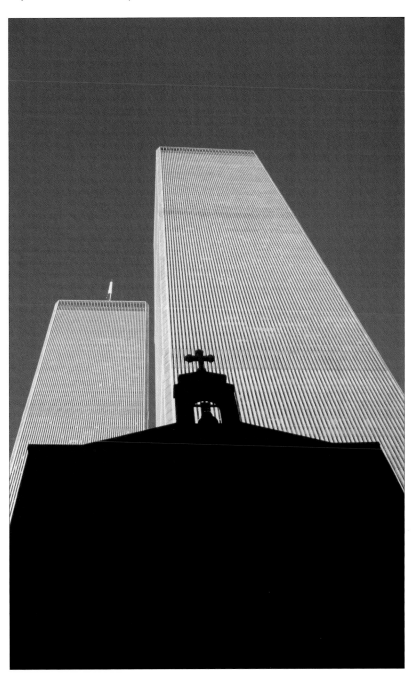

4 The Aftermath

Like the day Pearl Harbor was bombed and the day President Kennedy was shot, September 11, 2001 will never leave the memory of anyone alive at the time. Almost every commentator on radio, on television, in magazines, and newspapers has said that the destruction of the World Trade Center's Twin Towers completely altered the way Americans view themselves and the world around them.

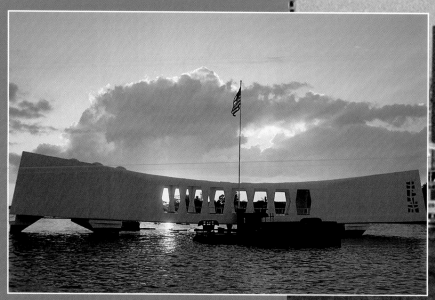

RIGHT

Among America's most important memorials is the one commemorating the loss of life at Pearl Harbor on December 7 in 1941.

FAR RIGHT

A sight no one will ever forget—the New York City skyline enveloped in a wreath of black smoke on the morning of September 11th.

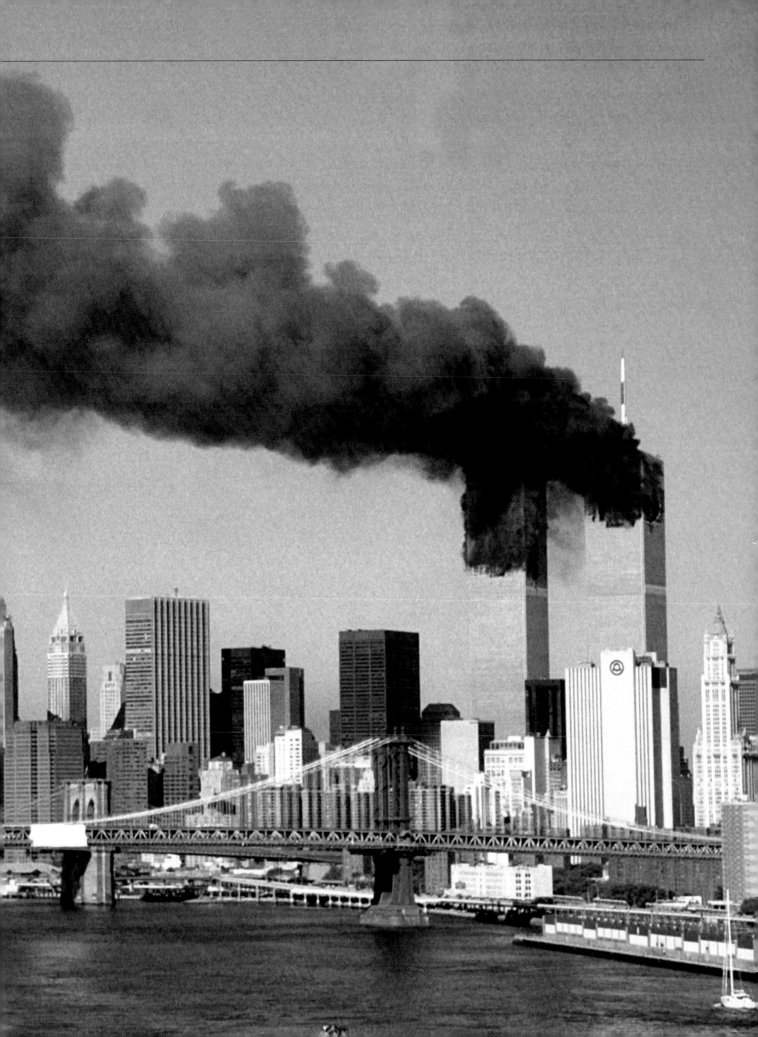

On the same day the World Trade Center was attacked, the Pentagon in Washington, DC was also partially destroyed by a suicide bomber in a highjacked airliner.

After fire melted the steel frames of the Twin Towers, the floors began crashing down, collapsing the ones below them like dominoes one at a time until nothing was left.

Nothing will ever be the same again, they say, and there seems to be no question that the assessment is accurate.

But apart from the sheer terror of watching 5,000 lives being snuffed out in a rain of fire, rubble, and smoke, and the audacity of the attack itself, the question that comes to mind is why the World Trade Center? Sure, it was an easy target for a hijacked airplane to hit and, as the terrorists' timing shows, it was a good way to kill the maximum number of Americans in an instant. Still, the question persists: why New York? The destruction of a portion of the Pentagon on the same morning sent a message, as almost any other target in Washington, DC would have, that war had been declared on the United States government, which is the people after all. Why single out anonymous citizens just going about the business of making a living? The answer, as with every other question about the motives of terrorists, can be summed up in a single word: symbolism.

The force behind America's cultural dominance is the inexorable expansion of democratic capitalism, and that force emanates out from the towers squeezed into lower Manhattan. They have become symbols of all the things the city and the nation is accomplishing. Any downtown building projects the image—indeed, the New York Stock Exchange would have made a more effective target as metaphor for capitalism—but the Trade Center also had the distinction of representing international capitalism. That made all the difference.

No one knows exactly for certain who was behind this attack—although all agree that Osama bin Laden and his network are the likely culprits—but in the end the question of why anyone might do such a thing becomes more important. These people looked at the tip of Manhattan and saw a symbolic villain that, to their perverted way of thinking, was slowly killing their own values and way of life. The idea brings on feelings of hatred and a need to do something to save their own freedom to live their lives according to their beliefs. A natural way to ease those feelings is to plot the death of the enemy. Although Americans don't perceive themselves as anyone's enemy, to such fanatics they are evil personified. And that perception applies especially to the capitalists working in the World Trade Center. In their opinion, even the lowliest clerk is considered a conspirator in the broad plot to subjugate Third World societies.

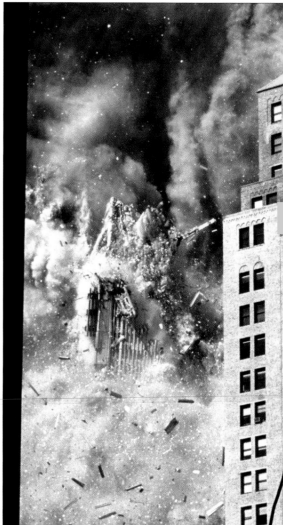

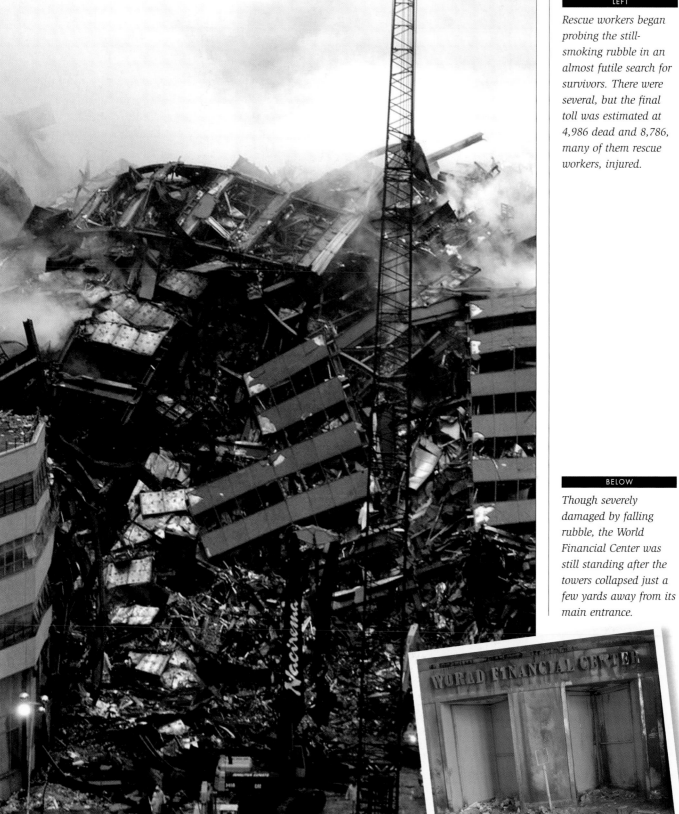

Rescue workers began probing the still-smoking rubble in an almost futile search for survivors. There were several, but the final toll was estimated at 4,986 dead and 8,786, many of them rescue workers, injured.

Though severely damaged by falling rubble, the World Financial Center was still standing after the towers collapsed just a few yards away from its main entrance.

In 1993, after a car bomb exploded in the Trade Center's basement garage, construction workers were on the job within hours to repair the physical damage, which was extensive.

While the buildings themselves would eventually be restored, the lives lost and the injuries suffered in the 1993 bombing could never be made right again.

THE PRECEDENTS

Among the artifacts destroyed along with the Twin Towers was a granite monument at the edge of the outdoor plaza. It was a memorial to the six people who lost their lives when a bomb went off in the underground parking garage in 1993. The blast not only killed six people, but a thousand others were injured and fifty thousand forced to relocate to another office. Some nine hundred workers at the Vista Hotel and at Windows on the World were forced to find new jobs as their old ones disappeared. The Port Authority relocated 350 tenant companies with relative ease in what was then a soft real estate market.

The car bombing was unprecedented, but the agency's antiterrorist unit, the Office for Special Planning, had issued a confidential report eight years earlier including a prediction that, "A time bomb-laden vehicle could be driven into the WTC and parked in the public parking area ... At a predetermined time, the bomb could be exploded in the basement ... The Assistant Deputy Director for the FBI thinks

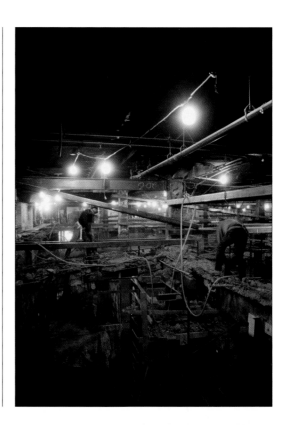

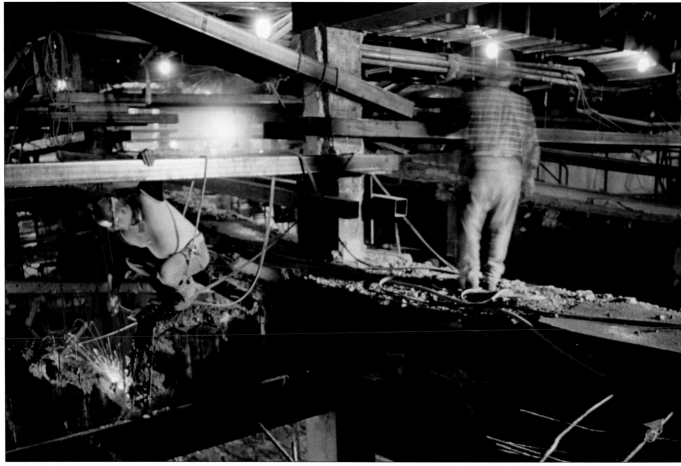

this is a very likely scenario for the WTC and has described it graphically in conversations with the OSP staff." When the blast actually happened, almost exactly as predicted, the thinking behind it was obviously an attempt to blast away the foundations of the tower above, causing it to collapse into its mate and send both of them tumbling down on the streets of Lower Manhattan. That it didn't happen that way was not because, in the opinion of an engineer who had worked on the original design, the van wasn't packed with enough explosives—there was more than enough—but that the terrorists had made the mistake of using "the wrong kind of bomb."

The idea of using bombs to wipe out the "evils" of capitalism was far from a new one in mid-century New York. Anyone walking past the Morgan Guaranty Trust building on the corner of Wall and Broad Streets can see a graphic reminder of an otherwise forgotten attempt to blow big money away. Just before the noon lunch break one fine autumn day in 1920, a heavily loaded horse-drawn cart was

pulled up outside the building and abandoned there, as though the driver had gone off to lunch. As workers were streaming out of the building, the cart suddenly exploded, killing thirty-three innocent bystanders and seriously injuring four hundred others, as well as ending the life of the poor horse who might be classified as a co-conspirator. In those days, all such acts of terrorism were automatically attributed to "anarchists," who were protesting the American system. But there were other suspects in this case. Among them was the head of the International Workers of the World, who was immediately arrested and held without charges, just in case it might turn out that the Communists were responsible. Scores of aliens, both naturalized and traveling on visas, were rounded up and deportation proceedings started against them. In Washington, a Democrat senator accused his Republican colleagues of being responsible because they hadn't provided the funds to fight the Red Menace seething under the surface of American society. A leading Protestant minister

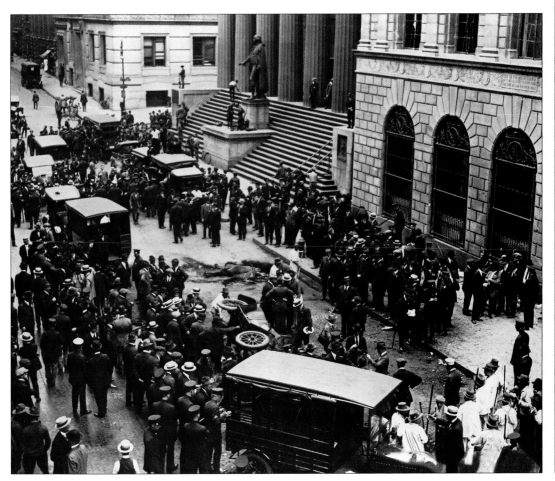

Wall Street was rocked by a bomb explosion at the Morgan Bank in 1920. Thirty people were killed and 400 others injured. After a long investigation, the case was closed and no culprit identified.

RIGHT

In 1899, a madman tossed a bomb into the downtown office of financier Russell Sage, who was fortunately elsewhere at the time and survived to continue with his philanthropies, possibly the most generous to city institutions of the nineteenth century.

RIGHT

While the Sherry-Netherland Hotel was under construction, a wooden scaffold around its tower caught fire, and firefighters weren't equipped to direct water that high. As it burned, all of the Fifth Avenue-facing rooms at the Plaza Hotel across the street were fully occupied.

showed up at his office one morning and casually asked the great man's secretary to hand over $1.2 million. When the secretary refused, Norcross tossed a small package into the room. It was a bomb that exploded on impact, killing the secretary and injuring eight other people who had the misfortune of also showing up to do business with Mr. Sage that day. Norcross was arrested, of course, and eventually certified insane, but there were no hints that his action was part of a wider conspiracy.

Possibly New York's most famous skyscraper disaster was clearly an accident, although there were some who believed it might have been the intentional action of one of the country's enemies. It happened in the waning years of World War II, when such a thing seemed easily believable.

On the morning of July 28, 1945, a Saturday when the building's population was at a near minimum, a US Army B-25 bomber came lumbering through a thick low cloud

laid the blame squarely at the doorstep of the Pope, who had allowed anarchistic tendencies to flower among his followers. A scientific analysis of the rubble in Wall Street confirmed suspicions that the explosive was TNT, and that there was probably twenty pounds of it packed into the back of the cart. But that was all that was known about the incident. The investigation, which involved an entire squad of city police detectives, was finally labeled "unsolved" in 1930.

An earlier example of bomb versus tower took place in 1899 in the city's first skyscraper, a 386-foot (118m) office building on Park Row at Beekman Street, a few short blocks from the future site of the World Trade Center. Among its tenants was Russell Sage, a financier who boosted his impressive personal fortune, estimated at one point to be more than $70 million in nineteenth-century dollars, by joining with the less-respectable Jim Fiske and Jay Gould in building the country's railroads. A generous man, he donated impressive funds to establish the YMCA and YWCA in New York, as well as the building of such institutions as the Museum of Natural History and the Metropolitan Museum. It seemed only natural, then, that he wouldn't mind making a small donation to a needy individual, and that man, in the person of one William Norcross,

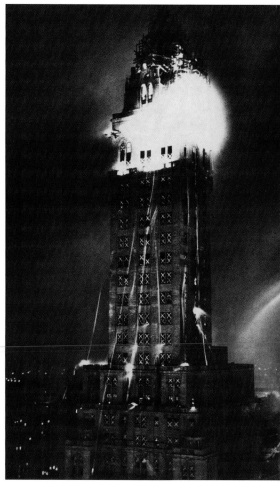

bank and crashed directly into the seventy-ninth floor of the Empire State Building.

The impact propelled one of its engines straight through the building and out the other side onto the rooftop of a building on Thirty-Third Street. Another engine was sheared off and sent plunging down an elevator shaft, leaving a conflagration of burning fuel in its wake. Fourteen persons were killed, a much lower figure than might have been the result of a similar impact on a busy work day, and the building itself only shuddered. The gaping hole in its uptown facade was repaired within weeks, and the building restored to its original condition without much inconvenience to the building's tenants. The cost of repairing the damage came to less than a million dollars.

REMARKABLE RESILIENCE

No matter what the disaster—a blizzard, a hurricane, a bombing, a fire, a transit strike, or a power blackout—New Yorkers pride themselves on their good-spirited coping. Even

ABOVE

In 1945, an army bomber lost in the fog crashed into the side of the Empire State Building. Apart from a hole in its side, the building withstood the impact with hardly a shudder. Fatalities and injuries were minimal because the crash took place on a sleepy Saturday morning.

LEFT

The gaping hole in the Empire State's side was repaired within weeks of the B-25 crash. Almost none of the building's tenants were even inconvenienced, but they never forgot the experience.

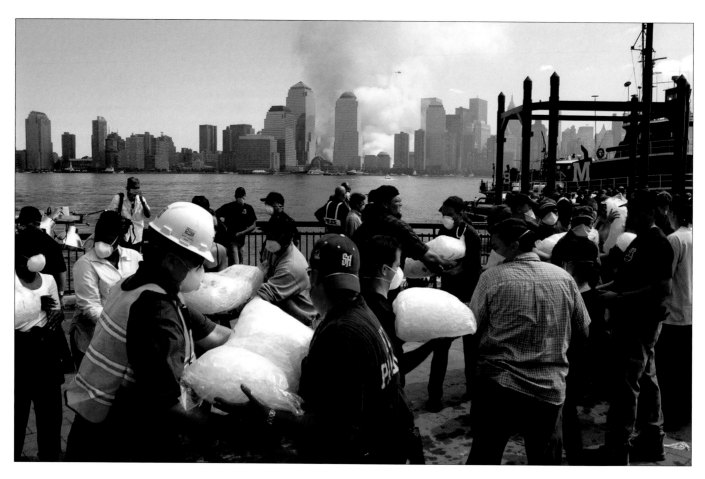

ABOVE

After the Trade Center attack, volunteers not only rushed to the scene but to the other side of the Hudson River, where they formed human chains to load supplies onto boats that would carry them to the workers near Ground Zero.

people who normally avoid talking to strangers suddenly became garrulous, and those who are usually friendly find new friends in shared adversity.

The personification of this attitude rose to the surface after the disaster at the Twin Towers in the person of Mayor Rudolph Giuliani. Before September 11, 2001, many people believed that his personality was best summed up by the Emergency Command Center he established on the seventh floor of 7 World Trade Center in 1998. It symbolized the public's perception of the mayor's bunker mentality, his tendency to circle the wagons and lash out in the face of criticism, however minor. In the opinion of many of his constituents, the mayor was nothing less than a hothead.

On the morning of the disaster, Giuliani wisely left his cocoon before the building came crashing down around it. He and his aides moved to another location nearby, but had to run for their lives when that building collapsed only ten minutes later. As he described the experience that afternoon, the city suddenly noticed a new Giuliani, a man of quiet

compassion and heart-felt sympathy for the victims of the tragedy, many of whom were his own close personal friends. He also summoned up new qualities of leadership that many observers hadn't noticed before when he assured his fellow New Yorkers that the federal government would respond in an appropriate way, and cautioned them against the natural inclination to lash back for instant revenge. He told them that they needed to put aside any thoughts of group hatred, particularly against their Muslim neighbors, and then apologized to them for even suggesting that New Yorkers could be capable of such a thing, which would be "beneath their dignity."

There was a primary election scheduled for that day for the parties to select their candidates to run against each other to succeed Giuliani, but before the day was over there were calls to suspend the law that prevented him from running for another consecutive term. The idea was eventually abandoned, but it was a sincere vote of confidence for a mayor who came through in the crunch just when the city needed him most.

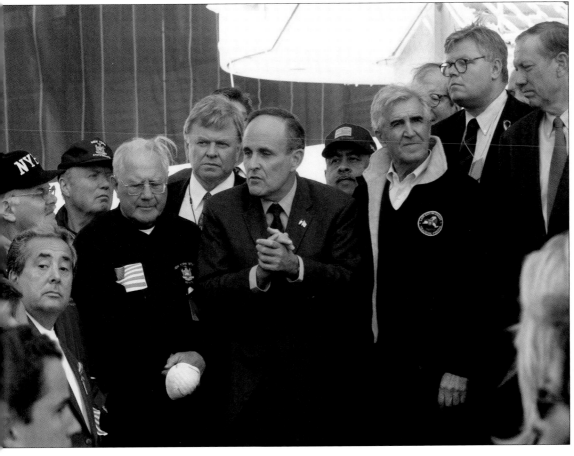

New York's Mayor Rudolph Giuliani was among those forced to run for their lives. In the days after, he gave new meaning to the term "City Father," as he patiently guided his constituents through their darkest days.

President George W. Bush arrived on the scene within days of the attack to thank rescue workers, police officers, and firefighters.

When the Stock Exchange reopened on September 17, the opening bell was rung by city firefighters.

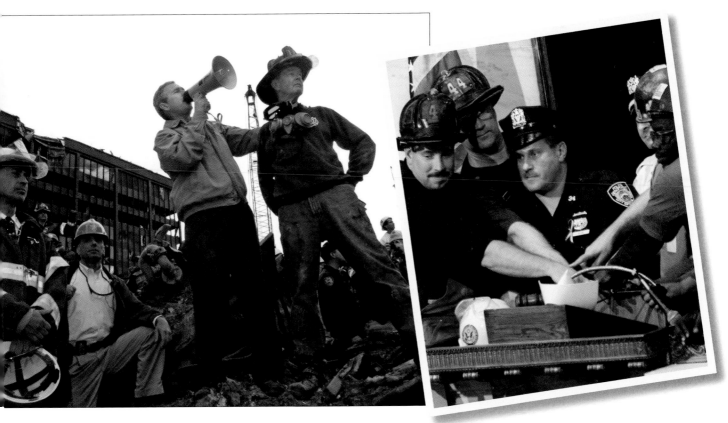

BUILDING A LASTING MEMORIAL

The man who replaces Giuliani at City Hall will preside over the healing and the rebuilding of the World Trade Center. Yes, it will be rebuilt, there never was any doubt of that. The first nod in that direction came within hours of the disaster in a statement made by Larry Silverstein, whose development company had closed a deal less than two months earlier to take control of the World Trade Center, along with its partner, Westfield America, for $3.2 billion. At the time of the disaster, the transformation of ownership was nearly complete, and the embattled Port Authority of New York and New Jersey had become just another tenant.

Silverstein wasn't the only one behind the movement to rebuild. Even as smoke was still rising from the crater, planners, developers, and architects were putting their heads together to plan for the future. Although few of them agree on how it should be done, they are all of a single mind that there is more at stake here than the simple rebuilding of a few blocks of Manhattan real estate. It is an opportunity to reinvigorate Lower Manhattan in ways the original World Trade Center failed to do. The whole project originally began with the hope of turning the area into a twenty-four-hour town, but opportunities were lost along the way, and now developers will be able to profit from the missteps of the past. They know what works and what doesn't. As Robert Yaro, the Director of the New York Regional Planning Association, put it, "Manhattan was the first twentieth-century city, with high-rises and mass transit—and now we have the opportunity to create the first twenty-first-century city."

Leaseholder Silverstein has proposed building four fifty-story towers there to replace the ten million square feet (929,000m²) of office space that was destroyed, and to rehabilitate the twenty-seven million square feet (2.5m²) of space that was damaged. Mayor Giuliani has called for preserving the seven-story remnant of the lost towers as a memorial. It is a certainty that there eventually will be both a replacement of the lost space and a memorial as well. But the jury is still out on what form it will all take.

It is generally agreed that the cleanup will take at least two years, plenty of time to

The gap left in the skyline by the loss of the Twin Towers is far less impressive than the site itself—a rubble-filled hole where life once pulsated.

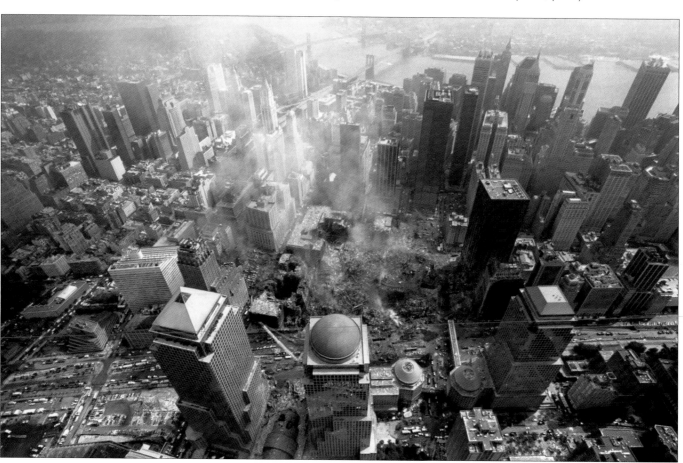

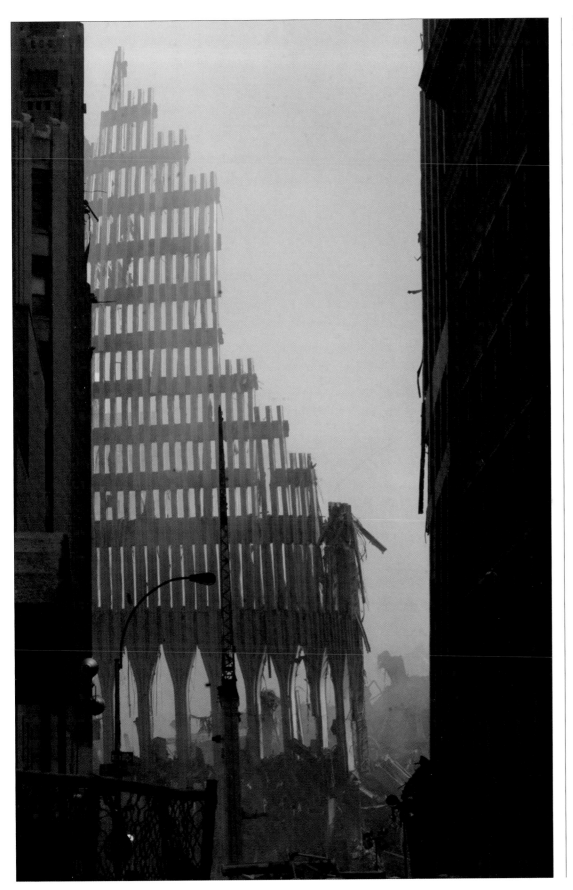

All that remains of the towers is a section of the Gothic window traceries from the bottom of one of them. It has been suggested that this fragment should be crafted into a memorial.

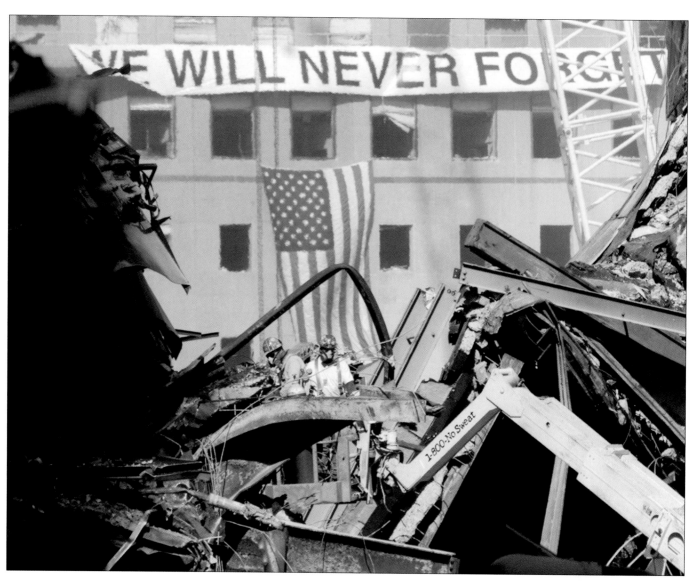

The cleanup of the site probably won't be complete until 2003. As it continues, the workers laboring over the debris-filled hole that was once an underground shopping mall are telling the world never to forget what happened here.

seriously compare proposals, and another five years to actually build the new Trade Center. In a poll conducted among leading architects by *The New York Times*, there is no consensus among them about what they would do if hired. Robert A.M. Stern, for one, was adamant that nothing less than a literal rebuilding of the towers would do. "They are a symbol of achievement as New Yorkers and as Americans, and to put them back says we cannot be defeated, " he said. Bernard Tschumi, Dean of the Columbia architectural school, had a different view: "Of course we should rebuild, bigger and better," he said. "There should be ... a mix of activities, both cultural and business. Yes, there should be a place to mourn, but that shouldn't be the main thing. It must be a place looking into the future, not the past." Terrence Riley, architectural

curator of the Museum of Modern Art, turned his opinion into a challenge: "Once we get over the grieving, we should realize that this could be a defeat, or it could be like Chicago after the fire, in 1871, when they invented the skyscraper and changed the ways cities have grown all over the world. We should build an even greater and more innovative skyscraper."

Is New York up to the challenge? There never was any doubt of that. Architect Richard Meier has pointed out that the life of the city depends on the people who live, work, and play there. They deserve nothing less than "a place that can be magnificent," he said, and as a native New Yorker himself, he knows very well that in the end that is exactly what they are going to get, and that is the best possible memorial to what we have lost.

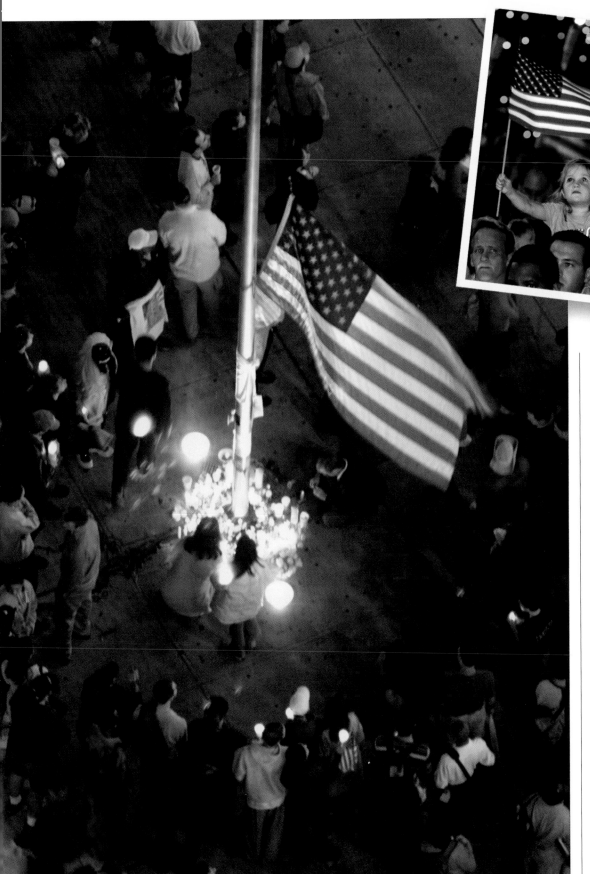

Young people, whose lives were changed by the disaster, will carry their flags into the future with a new outlook. It is they who will make all this change for the better one day.

After the disaster, churches reported near-record turnouts of worshippers, and candles and flags and silent mourners holding vigils began appearing in every neighborhood.

Dedication

This book is dedicated to all of the innocent victims of the tragedy at the World Trade Center on September 11, 2001. It also honors the families of those victims, as well as the police officers, firefighters, and emergency crews who unselfishly worked twelve-hour shifts to help make things right—along with those who rushed from points all over America to lend a hand. It is in thanks to all of the relief organizations that responded so quickly and caringly. And to ordinary New Yorkers who rallied together to do everything they could to soften the blow. Most of all, it is a grateful tribute to Mayor Rudolph Giuliani, an extraordinary New Yorker, who was so close to the scene at the beginning that he was nearly killed when the first tower collapsed. In the days that followed, his calm, patient, and reassuring demeanor steadied a city that might understandably have degenerated into a state of panic.

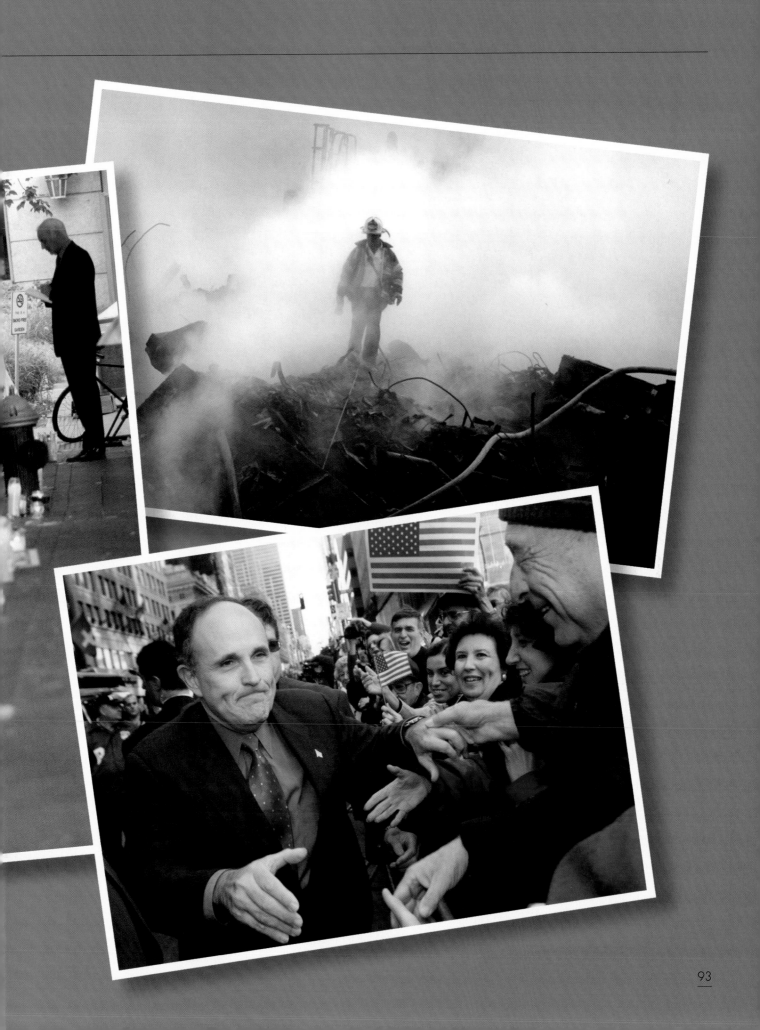

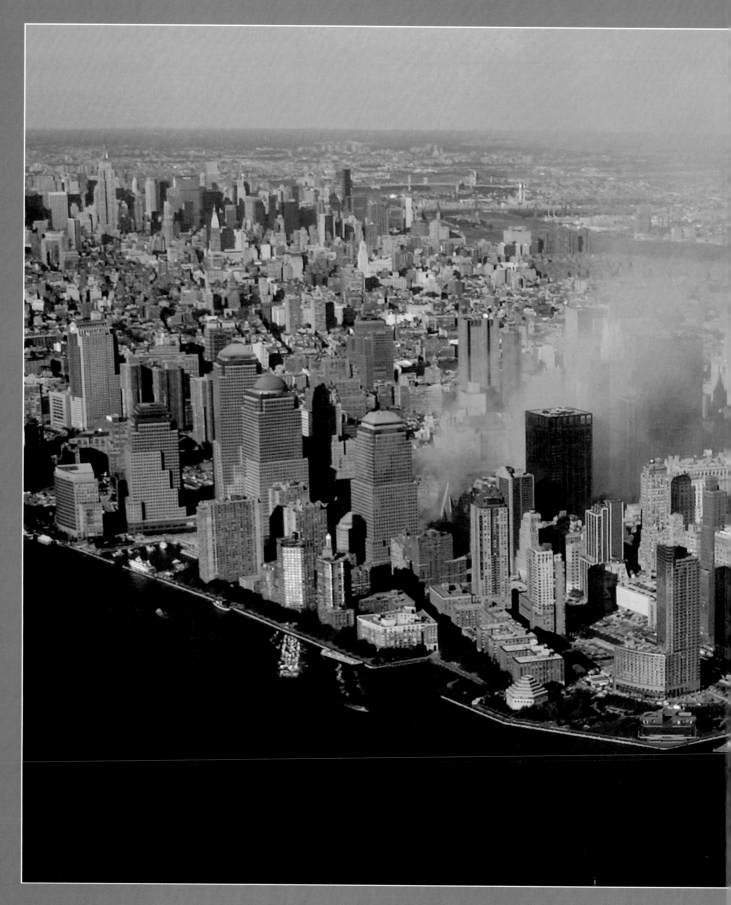

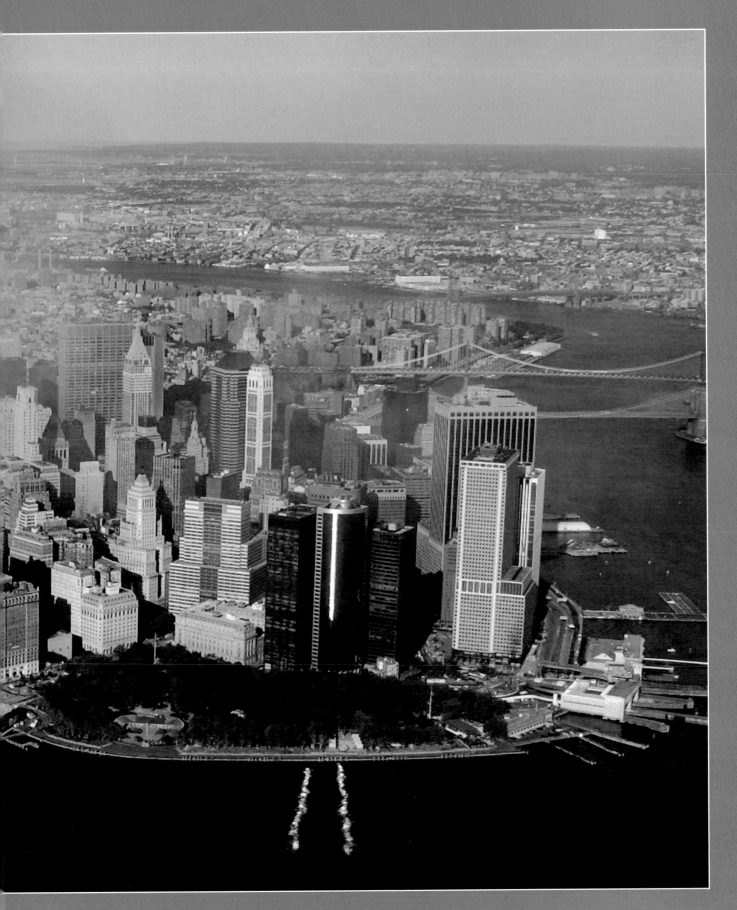

Acknowledgments

The publishers wish to thank the following photographers and picture libraries who have supplied photographs for this book. Photographs have been credited by page number and position on the page: (T) top, (B) bottom, (L) left, (R) right etc.

Front jacket International Stock; back jacket Chrysalis Images; 1–9 Chrysalis Images; 10 Gail Mooney/Corbis; 10–11 Museum of the City of New York/Corbis; 12 Gail Mooney/Corbis; 13(T) Hulton|Archive; 13(B) Simon Clay/Chrysalis Images; 14 Bettmann/Corbis; 15(T) Museum of the City of New York/Corbis; 15(B) Mary Evans Picture Library; 16(T) Archivo Iconografico S.A./Corbis; 16(B) Bettmann/Corbis; 17 Francis G. Mayer/Corbis; 18 J. Crino Collection/Hulton|Archive; 19(T) Museum of the City of New York/Corbis; 19(B) Chrysalis Images; 20(T) Bettmann/Corbis; 20(B) Historical Picture Archive/Corbis; 21(T) Bettmann/Corbis; 21(B) Bettmann/Corbis; 22 Hulton|Archive; 23 Mary Evans Picture Library; 24(T) Oscar White/Corbis; 24(B) Mary Evans Picture Library; 25(T) Hulton|Archive; 25(B) Mary Evans Picture Library; 26(T) Hulton|Archive; 26(B) Hulton|Archive; 27 Underwood & Underwood/Corbis; 28 Corbis; 29 Hulton|Archive; 30(T) Hulton|Archive; 30(BL) Bettmann/Corbis; 30(BR) Hulton|Archive; 31 Digital Vision; 32 Hulton|Archive; 32–33 Minoru Yamasaki; 34 Hulton|Archive; 35(T) Bettmann/Corbis; 35(B) Bettmann/Corbis; 36(L) Bettmann/Corbis; 36(R) Bettmann/Corbis; 37(T) Charles E. Rotkin/Corbis; 37(BL) Bettmann/Corbis; 37(BR) Bettmann/Corbis; 38 Bettmann/Corbis; 39(T) G.E. Kidder Smith/Corbis; 39(B) Timepix; 40 Hulton|Archive; 41(T) Hulton|Archive; 41(B) Bettmann/Corbis; 42 Slim

Aarons/Hulton|Archive; 43(T) Bettmann/Corbis; 43(B) Bettmann/Corbis; 44 Bettmann/Corbis; 45 Bob Gomel/Timepix; 46 Fox Photos/Hulton|Archive; 47 Minoru Yamasaki; 48 Hulton|Archive; 49(B) Hulton|Archive; 50(TL) Bettmann/Corbis; 50(TR) Bettmann/Corbis; 50(B) Hulton|Archive; 51 Hulton|Archive; 52(L) Hulton|Archive; 52(R) Hulton|Archive; 53 Hulton|Archive; 54 Hulton|Archive; 55 Bettmann/Corbis; 56 Simon Clay/Chrysalis Images; 57(T) Adam Woolfitt/Corbis; 57(B) Hulton|Archive; 58 Melvin Levine/Timepix; 58–59 Michael S. Yamashita/Corbis; 60 Bettmann/Corbis; 61(T) Bettmann/Corbis; 61(BL) AP Photos; 61(BR) Kobal Collection; 62 Bettmann/Corbis; 63(T) Bettmann/Corbis; 63(B) Gail Mooney/Corbis; 64(T) Richard T. Nowitz/Corbis; 64(B) Gail Mooney/Corbis; 65(T) Henry Groskinsky/Timepix; 65(B) Gail Mooney/Corbis; 66(T) Kelly/Mooney Photography/Corbis; 66(B) AP Photos; 67(T) Michael S. Yamashita/Corbis; 67(B) International Stock; 68(T) Craig Lovell/Corbis; 68(B) Richard Hamilton Smith/Corbis; 69(L) Michael S. Yamashita/Corbis; 69(R) Michael S. Yamashita/Corbis; 70 AFP/Corbis; 71 Simon Clay/Chrysalis Images; 72 Kelly-Mooney Photography/Corbis; 73(T) Simon Clay/Chrysalis Images; 73(B) Bettmann/Corbis; 74(T) Jerry Cooke/Corbis; 74(B) Gail Mooney/Corbis; 75 Ted Thai/Timepix; 76(TL) Michael Levine/Timepix; 76(TR) Simon Clay/Corbis; 76(B) Robert Holmes/Corbis; 77 James Marshall/Corbis; 78 Chrysalis Images; 78–79 Reuters; 80(T) Reuters; 80(B) Reuters; 81(L) Reuters; 81(R) Reuters; 82(T) H. David Seawell/Corbis; 82(B) H. David Seawell/Corbis; 83 Corbis; 84(T) Corbis; 84(B) Hulton-Deutsch Collection/Corbis; 85(T) Hulton|Archive; 85(B) Bettman/Corbis; 86–95 Reuters